# LEGENDAR

## OF

# COVINGTON

## KENTUCKY

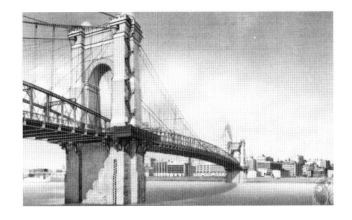

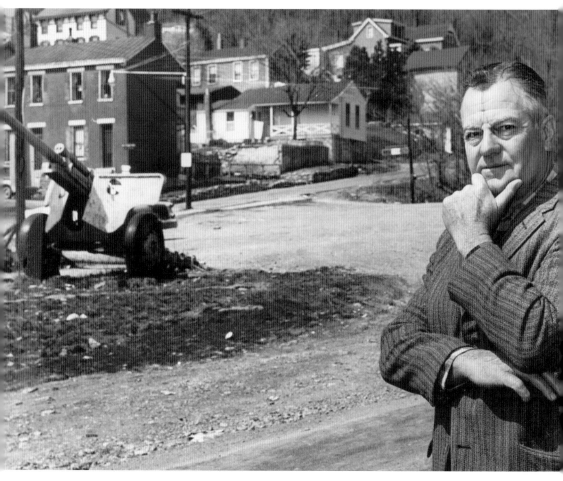

**Superintendent of Devou Park Vince Keller**
Vince Keller, longtime superintendent of Devou Park, stands on Montague Road. Devou Park, one of the gems of recreation in the tri-state area, was established in 1910 when William Devou donated 500 acres to the City of Covington for a park. (Courtesy of Kenton County Public Library.)

**Page 1**: **Roebling Suspension Bridge**
The great Roebling Suspension Bridge was designed by John A. Roebling. Construction began in 1856. (Courtesy of Kenton County Public Library.)

LEGENDARY LOCALS

OF

# COVINGTON
## KENTUCKY

ROBERT SCHRAGE

Legendary Locals is an imprint of Arcadia Publishing
Charleston, South Carolina

Printed in the United States of America

Library of Congress Control Number: 2014934527

For all general information, please contact Arcadia Publishing:
Telephone 843-853-2070
Fax 843-853-0044
E-mail sales@arcadiapublishing.com
For customer service and orders:
Toll-Free 1-888-313-2665

Visit us on the Internet at www.arcadiapublishing.com

**Dedication**
*With love to Andrew J. Schrage (1989–2011)*

**On the Front Cover:** Clockwise from top left:
Ben Bernstein, business leader (Courtesy of Kenton County Public Library; see page 55), George Steinford, philanthropist (Courtesy of Kenton County Public Library; see page 62), Caroline Williams, artist (Courtesy of Kenton County Public Library; see page 86), James Simpson, community leader (Courtesy of Kenton County Public Library; see page 40), Dr. R. Hayes Strider, educator (Courtesy of Kenton County Public Library; see page 121), Clay Wade Bailey, journalist (Courtesy of Kenton County Public Library; see page 58), Kenny Price, musician (Courtesy of Kenton County Public Library; see page 103), Frank Duveneck, artist (Courtesy of Kenton County Public Library; see page 110).

**On the Back Cover:** From left to right:
Judge Donald Wintersheimer, Kentucky Supreme Court justice (Courtesy of Kenton County Public Library; see page 34), Dave Cowens, basketball player (Courtesy of Kenton County Public Library; see page 99).

# CONTENTS

# ACKNOWLEDGMENTS

The author acknowledges the assistance of many individuals, including my dear friend Kevin T. Kelly and David Schroeder, executive director of the Kenton County Public Library. Without the assistance of these two individuals this book would not have been possible. Also, I would like to thank Bernie Spencer for all his work on Northern Kentucky Views. It is such a valuable tool and he does a tremendous job preserving Northern Kentucky history. Thank-yous go to the authors of *The Encyclopedia of Northern Kentucky* for their great book, which helped immensely with profiling these Covington legends. A special thank-you also goes out to each of the contemporary figures appearing in this book who cooperated by providing a photograph and telling his or her story.

# INTRODUCTION

Located directly across the Ohio River from Cincinnati, the city of Covington was established in 1815 on 150 acres of land purchased by Thomas Carneal and Richard Gano. Both of these individuals invested a total of $50,000 and called their effort the Covington Company, after War of 1812 general Leonard Covington, who had his troops in the area. In some ways, Covington was the perfect place to locate a new city. Cincinnati was already well established, and Covington would be served by two rivers: the Ohio to the north and the Licking to the east.

Originally, the land was owned by Thomas Kennedy, who possessed 200 acres at the mouth of the Licking River. Kennedy, a Campbell County Court justice, soon operated a ferry and a tavern. His ferry became a very successful route, especially because it lay on the route of the old Lexington Pike. Once travelers reached the area, the ferry was the best way across the river to Cincinnati. Eventually, Kennedy sold 150 of the acres to Carneal and Gano. On August 31, 1815, by action of the Kentucky General Assembly, the plat of Covington was recorded. The town was named after Covington, who died over a year and a half earlier in the Battle of Crysler's Farm in Canada.

Author Tom Dunham writes that many may have thought the "new town would not survive infancy." The War of 1812 had recently ended, and the Depression of 1819 made expansion west very hard and greatly hampered the growth of commercial enterprises. However, the town did very well. In 1830, the population was 715, but by 1840 it grew to 2,026. Covington would never decrease in population until the 1930s.

The first industry, according to the *Encyclopedia of Northern Kentucky*, was developed with money from Cincinnati and Philadelphia investors, who built a cotton mill. Other industries such as pottery and tobacco followed. Just 15 years after its founding, Covington saw fast and large German immigration. This led to the Kentucky General Assembly incorporating the town in 1834. The population almost tripled between 1830 and 1840.

As a newly incorporated city, Covington held its initial election in April 1834, and Mortimer M. Benton was elected as the first mayor. Benton was born in 1807 in New York. A lawyer by profession, he did something that changed Covington forever. Benton is widely credited with helping the Covington & Lexington Railroad with obtaining its first charter. He became president of the railroad in 1850. By 1854, the railway was already completed to Paris, Kentucky, and connected to Lexington via the Maysville & Lexington Railroad. Covington would forever be known in part as a railroad town, and its impact on the development of the community is tremendous. Covington had good railroad service, was located near Cincinnati, and in 1834 the Kentucky Legislature approved the creation of the Covington-to-Lexington Turnpike. Though slow to be constructed, it gave Covington excellent transportation options, especially when combined with the Ohio and Licking Rivers. Construction on the Roebling Suspension Bridge would start in 1856, giving another transportation option, this time connecting to Cincinnati, Ohio. Just as importantly, it spurred economic development. However, it was not completed until 1867, having been delayed by the depression of 1857 and the Civil War. The bridge would change many times over the years and still remains a vital link to Cincinnati. Thirty years after its construction, it would be made to accommodate streetcars. Of course, today it is used for automobiles and is a well-traveled pedestrian bridge.

The city of Covington, while the two convergent rivers were vital to its development, never became a public landing for boats, especially steamboats and others that drove the economy of so many river communities. Cincinnati had developed an active public landing in part both because it was more established than Covington and the Ohio River was shallower on the Kentucky side. Facilities existed

on the Cincinnati side of the river for boats. While cotton was the first industry in 1828, a commercial center developed around 1831. It was located between Third and Fourth Streets and Scott and Greenup Streets. Businesses did quite well in this area for a long time.

In 1840, Kenton County was carved out of Campbell County. Covington became the economic, social, and political center of the new county. Even today, while Independence is officially the county seat, Covington is still the home of the County's political power.

By 1850, Covington was the second-largest city in the state of Kentucky. As the population continued to grow, new land was annexed. Other railways followed the original Covington & Lexington Railroad. Irish Immigrants settled alongside the Germans already in Covington. In 1853, the Roman Catholic Diocese of Covington was established. By 1870, the population of Covington was 24,505; in 1880, 27,720. As the 1800s turned into the 1900s, Covington continued to see great expansion. In 1900, the population reached 42,938. The population of the whole of Kenton County, where Covington is located, was only a little over 20,000 more. Covington began annexation of small cities such as Central Covington in 1906, and Latonia and West Covington in 1909. By 1910, the population was 53,270. Two events occurred around this time that changed both the landscape and health care of Covington. First, in 1910, the Catholic Church finished the Cathedral Basilica of the Assumption, an outstanding Gothic Revival structure still dominating the landscape of Covington. Construction of the cathedral began in 1895, during the time of the third bishop of Covington, Camillus Paul Maes. The congregation was growing and the new cathedral replaced an old frame church used since 1834. The cathedral is considered to be a minor basilica, as designated by Pope Pius XII in 1953. Second, the Roman Catholic Church established a modern St. Elizabeth Hospital in 1909 by purchasing land at 21st Street and Eastern Avenue. While the roots of the hospital dates back to 1861 when Henrietta Cleveland and Sarah Peter established the first hospital in Northern Kentucky, the new hospital had a dramatic effect on the still-growing city. The new hospital was a four-story building designed by Samuel Hannaford & Sons and opened in 1914. Many, if not most, of the people identified in this book as "Legendary Locals of Covington" were born at this hospital.

Economic prosperity was unlimited in Covington in the early 20th century. The downtown saw great growth, including the creation of a healthy banking, shopping, employment, and entertainment district. Covington became the commercial and economic center of Northern Kentucky. Department and other stores flourished, and today the names roll of the tongue like old friends—Eilerman's & Sons, Coppin's Department Store, Marx Brothers Furniture, Tillman's, and Motch Jewelers. Long-established businesses flourished and new ones started. The banking center included Fidelity Building and Loan, First National Bank, German National Bank, Citizens National Bank, Covington Savings Bank and Trust Company, Peoples and Savings Bank and Trust Company. Covington's first bank, the Northern Bank of Covington, struggled and closed in the late 1800s.

Building construction surged during the time of economic prosperity. Many of the city's treasures of today were constructed during this time. Examples include the Times Star Building, Masonic Lodge, and most of the buildings on historic Madison Avenue. Some have been lost, including the beautiful City-County Building built in 1902 and razed in 1970. The city became wealthier, as explained by Dunham. Real estate valuation increased from $26.4 million in 1921 to $43.3 million by 1930. The manufacturing sector also flourished. Stewart Iron Works became a world-renowned company; breweries developed; and, in 1918, Wadsworth Electric Manufacturing Company started business and had tremendous growth and success. During this time in the city's history, other great things happened. Goebel Park was acquired, as was Devou Park, today one of the region's most beautiful and well used parks.

However, the great economic times, growth, and population increases were not to last. During the 1930s, for the first time, the population of Covington actually decreased—from 65,252 in 1930 to 62,108 in 1940. It would go up again by 1950, to 64,452, but it has decreased every decade since. By 2000, the population was 43,370. Most importantly was the flight to the suburbs. Years earlier, the streetcar extended south, and the Brent Spence Bridge and the construction of I-75 in the early 1960s dramatically altered the landscape of the region, including the expansion of the suburbs. Cities south of Covington flourished as Covington's population decreased and its economy suffered. The Great

Depression hurt Covington, as it did most of the nation; by the 1960s, however, the bottom fell out. Long-term Covington businesses closed: Eilerman's in 1973, Goldsmith's in 1966, and later Coppins, Marx, JC Penney, Montgomery Ward, Woolworth's, and Sears. Florence, Kentucky, and the Florence Mall became the retail center of Northern Kentucky.

However, Covington has seen a new beginning in recent years. Despite another decade of declining population—the population in 2012 was 40,713, but in 2000 was 43,370—good things are happening. New development has sprung up in the last 20 years that is redefining Covington. In 1990, the first phase of RiverCenter, a development that has transfigured the riverfront, was started. It includes office space (1997–1998) and a hotel (1999). Other developments include the Gateway Center (2001), the Northern Kentucky Convention Center (1998), the Justice Center (1999), the federal courthouse (1999), the Transit Center (1999), the midtown parking garage (2002), the restoration of the old Woolworth building into the Madison Banquet Hall (2002), restoration of the Madison Theater (2001), restoration of the Odd Fellows Hall (2005), restoration of the Northern Bank of Kentucky Building (1999), and the world-renowned Assent (2007), a unique condominium designed by Daniel Libeskind. In 1994, Fidelity Investments established a campus in Covington employing a couple thousand individuals.

Today, the city of Covington's run of good projects continues, including the location and expansion of an urban campus for Gateway Community and Technical College and urban walking trails along the Licking River. As the City of Covington's website advertises, "Covington's urban core spans from the Ohio River south to 12th/Martin Luther King Jr. Boulevard and from the Licking River westward to I-71/75 and the Brent Spence Bridge, and has many gems for the urban explorer. The best way to experience downtown is to just get out and start walking around." Today, Covington, much like the Greater Cincinnati region itself, is very walkable, and resources are being put into making the communities along the Ohio River even more walkable. Covington has long been known for its neighborhoods that make up the fabric of the community. Some are Austinburg, Wallace Woods, Peaselburg, Latonia, Botany Hills, and Rosedale. Neighborhood associations were formed decades ago and have led to beautification and other improvements to the various sections of Covington.

Covington still has challenges ahead. Its housing stock still is in great need of repair, and its historic downtown needs constant attention to succeed. Not only is economic development a constant priority, but so is community development. As with any aging urban community, the infrastructure is old, the housing stock often in disrepair, and a lack of urban appreciation is lacking from the suburbs. However, times are changing, especially as more people are discovering the charms and benefits of living in a historic urban core, somewhat free of the generic nature of many American cities. There is much to be proud of in the history of Covington and in its achievements in recent years. However, there is still much to accomplish to make the city healthy once again.

The answer to Covington's future is the same as its past: It is the legendary locals making up the community. Like the past, Covington is filled with great people who make a difference. The legends of the past 200 years in Covington history built something special. Tomorrow's legends can learn something from these pioneers. Their charge is not to construct a community, but rather to build upon its foundation laid by so many. By meeting these pioneers or local legends, we can learn about the great impact Covington has had on their lives, as well as see how they have touched the community. Their stories are both interesting and inspiring.

# CHAPTER ONE

# Founders

Like all the pioneers in American history, the early founders of Covington were tough individuals. They had to build something out of nothing. Early Covington was nothing more than farmland. Many pioneers built homesteads out of barren land, and western expansion was at full force. America was being built, and the city of Covington was at the forefront of this expansion, serving as a gateway to the West. American history is full of famous names of individuals who forged a nation out of the land; many other names are lost to history. In Covington, the pioneers that built the community faced a tough challenge. When Thomas Carneal and John and Richard Gano invested in land, they built a community at a time of war and depression. The city of Covington was laid out in line with Cincinnati, Ohio, the community to the north. Streets met each other in alignment, even though a great river separated the two. From the very beginning, it was well planned.

Richard Gano did not live to see many of his dreams completed. He died in 1815, and his brother John was left to see their dreams of a great community fulfilled. John died seven years later in 1822, but by then much of the groundwork was started and war and depression were over. Thomas Carneal lived until 1860 and is today one of the most prominent historical figures of the area. In part, this is due to the Carneal House, which bears his name and is one of the great mansions in the region. Carneal would become an influential citizen and a large landowner in other parts of Northern Kentucky.

These founders of Covington were brave men willing to dream big—to build a community out of farmland. They succeeded in this great vision, and today Covington owes much to these individuals. Their stories are both compelling and typical of the pioneers that built so much of this country.

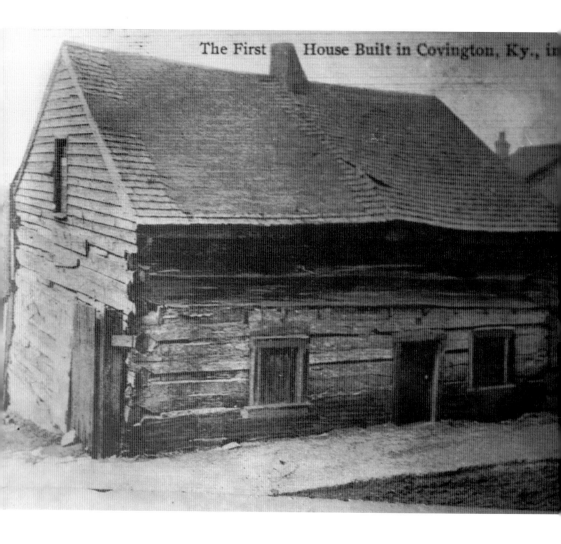

The First    House Built in Covington, Ky., in

## Leonard Covington

The city of Covington is named after Gen. Leonard Covington of Maryland. Born in Aquasco, Maryland, in 1768, he obtained "a liberal schooling," according to the Biographical Directory of the US Congress. He entered the military at age 24 as a cornet of cavalry, was commissioned lieutenant of dragoons in 1793, and joined the Army under General Wayne. He distinguished himself during the Battle of Fort Recovery and the Battle of Miami. According to research available at the Maryland State Archives (msa.maryland.gov), he was captain within a year but resigned on September 12, 1795, to pursue agricultural interests. He was married for the second time in 1796 and had five children. Covington served as a member of the Maryland House of Delegates for many years and was elected as a Democrat-Republican to the Ninth Congress and served as a US Representative from 1805 to 1807. The Democratic-Republican Party, or Republican Party as it was called then, was organized by Thomas Jefferson and James Madison in opposition to the Federalist Party that had dominated national politics until 1800. The Democratic-Republican Party controlled the presidency and Congress for the next 25 years. Its philosophy was Jeffersonian democracy and states' rights. Covington was appointed as a lieutenant colonel of the Light Dragoons in 1809 and as a colonel a month later. He was in command at Fort Adams on the Mississippi in 1810 and took possession of Baton Rouge and a portion of West Florida. He was ordered to the northern frontier in 1813 and appointed brigadier general. Wounded at the Battle of Crysler's Farm on November 11, 1813, he died three days later in French Mills, New York. His remains were moved to Sackets Harbor in Jefferson County, New York, in 1820 . The burial location is now known as Mount Covington. Many American communities are said to be named after Covington, including in Virginia, Louisiana, New York, Georgia, Alabama, Pennsylvania, Tennessee, and Mississippi. He was chosen to be the namesake of Covington, Kentucky, because he once trained troops in the area, according to historian Tom Dunham. (Both, courtesy of Kenton County Public Library.)

*Sally Howell Stanley, widow and sister of first wife of Nicholas Longworth*

## Thomas Carneal House

Thomas Carneal was born in 1786 in Alexandria, Virginia, and was one of the primary founders of the city of Covington. His family moved to Franklin County, Kentucky, when he was a young child and eventually settled in the Northern Kentucky area. Carneal stayed in the Cincinnati area after his parents moved back to Franklin County. He proceeded to establish himself in business and, according to the *Encyclopedia of Northern Kentucky*, went into the military supply business with Newport's founder, James Taylor Jr. In partnership with Taylor and others, Carneal established a bank in Campbell County in 1814. That same year, Carneal, the Gano brothers, and James W. Bryson purchased from Thomas Kennedy 150 acres for $50,000 in what would become Covington. In 1815, Carneal was hired to survey streets and roads in Newport and married Sarah Howell Stanley, the sister of Nicholas Longworth, the famous Cincinnatian. In 1820, Carneal built one of the great Northern Kentucky buildings, Elmwood Hall, in Ludlow. The Carneal House in Covington is well known as a legacy of Thomas Carneal and is rumored to have been an Underground Railroad stop. The residence, located at 405 East Second Street, is believed by many it to be the oldest structure in Covington. The two-story home was visited by many prominent individuals, including a rumored visit by hero of the Revolutionary War the Marquis de Lafayette during his famous tour of America in the mid-1820s. While technically known as the Gano-Southgate House, it is well known as the Carneal House because Carneal most likely designed and built it. Carneal continued to engage in business and sold land to the first large manufacturing business to be established in Covington. Three years later, he sold his residence to a developer who established the Covington Rolling Mill. Carneal continued to be active in land development through the remainder of his life. His wife, Sarah, died in 1847 and he moved to Frankfort. He died on November 8, 1860, and is buried in Spring Grove Cemetery in Cincinnati. According to the *New York Times*, he "amassed a handsome fortune" during his lifetime and "died of dropsy" at the age of 76 "at the residence of Nicholas Longworth, Esq., of Cincinnati." (Courtesy of NKY Views.)

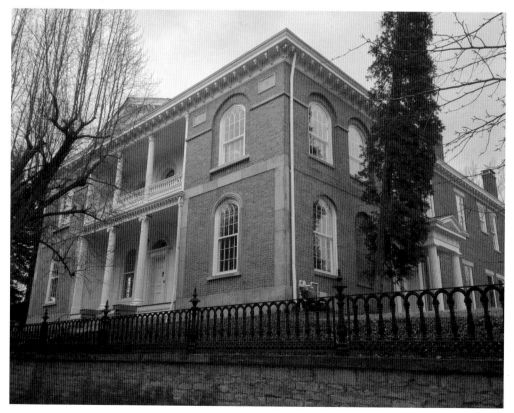

# CHAPTER TWO

# Community Builders

The community builders of Covington are wide in range and include individuals from business, philanthropy, charity, and other fields who helped build Covington in its early years. While the likes of Gano and Carneal helped found Covington, many other people helped make it what it is today. Community builders vary by generations as the ancestors of one built upon the legacy of the other. There are many great community leaders today; however, those individuals early in the city of Covington's history made it all possible.

As a result of the efforts of many, Covington has developed into a vibrant city. Community leaders have built Covington, and in many cases had to rebuild the city because of economic decline or other problems facing urban communities—it could be hospitals, bridges, businesses, parks, social services, or housing. Community builders are the people with the courage or wherewithal to get it done. It is a never-ending battle. In the early days, it was manufacturing, farming, population growth, or the small business owner opening a saloon or grocery store. As the city grew, other needs developed. The first St. Elizabeth Hospital opened in 1861. Transportation developed from the beginning and has greatly expanded for generations to come. People banded together to build churches, lodges, and other social organizations. The common denominator of all community development is people. Individuals joined forces or showed tremendous leadership to bring a community together and helped build it for future generations. Many citizens of Covington had to overcome tremendous odds to lead. African Americans had discrimination to contend with, but they rose above obstacles to achieve greatness. Covington has many leaders that will be identified in this book; however, a few people have been profiled in this chapter because of their unique impact on building or rebuilding Covington.

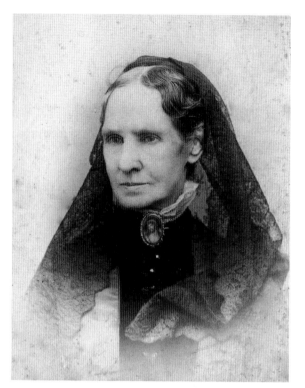

### Henrietta Cleveland

Born in 1817, Cleveland dedicated her life to works of charity and became good friends with Sarah Worthington King Peter. Together, after Cleveland convinced the first bishop of Covington, the two ladies started St. Elizabeth Hospital in 1861. They raised funds for the first building. Cleveland died in 1907 at the age of 90 and is buried in St. Mary's Cemetery in Fort Mitchell. (Courtesy of St. Elizabeth Healthcare.)

### Sarah Worthington King Peter

Peter, born in 1800, was a philanthropist and the daughter of Ohio governor Thomas Worthington. Her first husband, Edward King, passed away in 1836. She was later married to the British consul at Philadelphia, William Peter, and two years later became a devout Catholic. Together with Henrietta Cleveland, she raised money for St. Elizabeth Hospital. Peter was active in many foundations and during the Civil War volunteered as a nurse. She died in 1877 in Cincinnati. (Courtesy of St. Elizabeth Healthcare.)

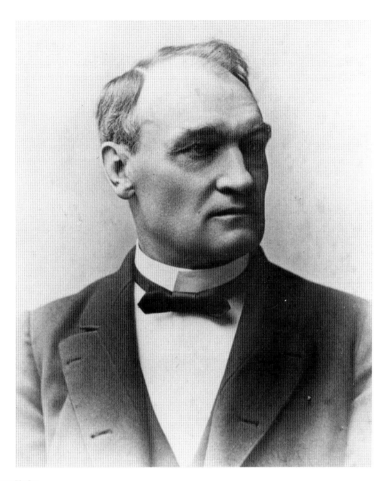

**John G. Carlisle**

Carlisle was a successful lawyer in Covington. Born in 1834, he would spend part of the 1860s in the Kentucky House of Representatives and two terms in the Kentucky Senate. He was a very bright individual and was hired as a teacher in the Covington school system before the age of 16. He quit teaching to pursue law. His mentor, John White Stevenson, later served as Kentucky governor. Carlisle would serve as Kentucky lieutenant governor from 1871 to 1875 and, upon the end of his term, ran for the US House of Representative from the Sixth District. He won this election and served for six consecutive terms, including as the speaker of the house from 1883 to 1889. Carlisle became the leader of the conservative Bourbon Democrats and was thought of as a potential presidential candidate but was passed over several times. In 1890, he was appointed to the US Senate to fill the unexpired term of James B. Beck. When Grover Cleveland was elected to the second of his two nonconsecutive terms as president, he picked Carlisle to be secretary of the treasury. Unfortunately for Carlisle, the Panic of 1883 struck during his term, effectively ending his political career. Further hurting his career were opposition to a tariff bill liked by rural members of his party and his position on ending silver coinage. Very unpopular, Carlisle returned to Covington but eventually moved to New York City, where he resumed the practice of law. In 1897, before moving from Covington, he was booed off the stage and, some say, hit with rotten eggs. The incident took place at the Odd Fellows Hall at Fifth and Madison Avenues. At the age of 75, he died in New York City on July 31, 1910. Carlisle is buried in Linden Grove Cemetery in Covington, and an elementary school bears his name. Carlisle County in Kentucky was founded and named in honor of Carlisle at the height of his political career, during his time as speaker of the house in 1886. (Courtesy of Kenton County Public Library.)

### John A. Roebling

John A. Roebling was a famous bridge builder born in Prussia in 1806. In 1856, he began work on the suspension bridge over the Ohio River between Covington and Cincinnati. Completed in 1867, it was the longest suspension bridge in the world at the time. According to the *Encyclopedia of Northern Kentucky*, Roebling's father operated a tobacco store in Prussia and his mother was "very ambitious." She instilled education and hard work in each of her five children. An engineer by training, Roebling studied bridge building. He had many successful projects, but the most famous was the Brooklyn Bridge in New York, which was started in 1869. The Roebling Suspension Bridge in Covington is one of the most famous and important structures in the Greater Cincinnati area. Roebling died in 1869, the result of an accident while surveying for a tower at the Brooklyn Bridge project. (Above, courtesy of Kenton County Public Library; right, courtesy of Kevin T. Kelly.)

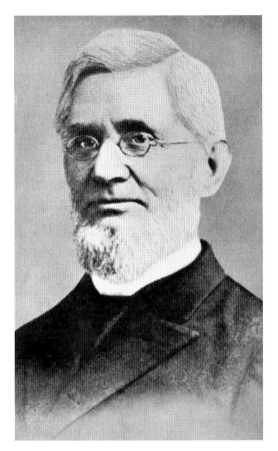

## Amos Shinkle

During the last half of the 19th century, Amos Shinkle was the leading philanthropist in the area and one of Covington's richest citizens. A Civil War veteran, he was born in 1818. His business interests encompassed coal, steamboats, and banking, including the creation of the first National Bank of Covington. As a major stockholder in the Covington and Cincinnati Bridge Company, he financed the construction of the Roebling Suspension Bridge. (Courtesy of NKY Views.)

## Benjamin Howard

B.F. Howard was born in Covington in April 1860 and died there on May 4, 1918. Throughout much of his life, his race hampered him from chartering African American Elks lodges. Howard, however, did establish Elks lodges in face of this discrimination. In 1916, he was able to incorporate Ira Lodge No. 37 in Covington and was made its first exalted ruler, according to the *Encyclopedia of Northern Kentucky*. (Courtesy of Kenton County Public Library.)

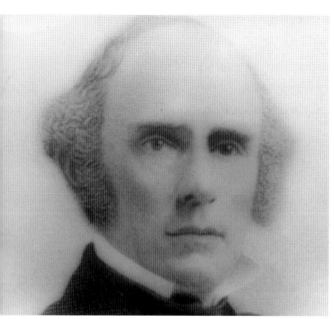

**Mortimer Murray Benton**

Mortimer Murray Benton was the first mayor of Covington, serving from the date of incorporation on February 24, 1834, until his resignation on October 2, 1835. Benton was born in New York State on January 21, 1807, and died on March 5, 1885, in Covington. After serving as mayor, Benton remained active in Covington politics and also became the president of the Covington & Lexington Railroad. (Courtesy of Kenton County Public Library.)

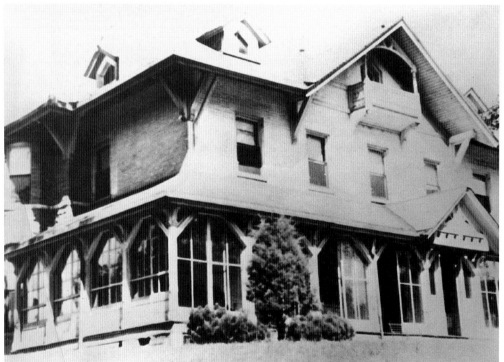

**William P. Devou**

Born July 15, 1855, Devou is most well known for donating with his brother 500 acres for a park in memory of their parents. William Devou was the owner of land around Covington and is said to have amassed around 250 properties. Devou died in Covington on December 8, 1937, after contracting pneumonia and refusing care. He died at St. Mary's Hospital in Cincinnati. Shown here is the Devou Home sometime around 1910–1924. (Courtesy of Kenton County Public Library.)

### Alice Thornton Shimfessel

Shimfessel was born June 27, 1901, in Xenia, Ohio, and died December 5, 1983, in Cincinnati. The daughter of the Reverend Isaac and Laura Thornton, she became one of the most important community activists in Covington during the 20th century. Her efforts were aimed right at the heart of racial discrimination in Covington, and she faced the key issues head-on, without trepidation. Married to Elmer Shimfessel, she became in 1941 the first secretary of the new Jacob Price housing project. According to the *Encyclopedia of Northern Kentucky*, "during the early 1950s she was at the forefront of the civil rights movement and accepted a challenge from the city of Covington and neighborhood residents to find a place for African American youth to play." A YMCA was created, and eventually the L.B. Fouse League was started with Shimfessel as the first league president. Again, according to the *Encyclopedia of Northern Kentucky*, "many civil rights activities, including Congress of Racial Equity freedom riders protest demonstrations, NAACP meetings, and teen dances were launched out of the L.B. Fouse League." She served as president of the local NAACP and was a delegate to the Congress of Racial Equality, which was founded in 1942 and became one of the nation's leading activist organizations in the early years of the American civil rights movement. Shimfessel was highly involved in protests and efforts to end segregation in restaurants, movie theaters, and department stores. The issue of public accommodation was instrumental to her causes as she fought for inclusion in public schools and businesses. In court, she supported an African American student's enrollment into Holmes High School. For over 50 years, Shimfessel was a member of the First Baptist Church and held a couple key positions over the course of her membership. In 2007, she was selected to the Kentucky Human Rights Commission Hall of Fame. The bravery, steadfast activism, and leadership of Shimfessel and others in the local civil rights movement helped make Covington a better place to live and work. Her impact continues to be felt. She is buried at Mary E. Smith Cemetery in Elsmere. (Courtesy of Kenton County Public Library.)

## Mary Moser

Mary Moser had a very long life, most of it spent in service to others. She was born and raised in Covington and died there at the age of 100. Born a few years before the turn of the century on March 17, 1897, she would live her entire life in Northern Kentucky. She attended La Salette Academy and following the death of her husband, in order to support a family, turned to social work. Her first job was in the welfare office of Kenton County. At this point in time, the field of social work was new and Moser was at the forefront of the profession. According to the US Department of Labor Bureau of Labor Statistics (BLS), social work is today one of the fastest-growing careers in the United States. The profession is expected to grow by 25 percent between 2010 and 2020. In 1948, an organization called Catholic Charities Diocese of Covington began its formal operations as a direct service provider, according to its website, in "two small rooms above a St. Vincent de Paul store in Covington, KY when Msgr. Klosterman hired Mrs. Mary Moser as a professional social worker. Originally a child welfare agency, licensed for child care and placement in 1949, the agency has grown to serve a wide variety of needs for the Northern Kentucky community. Catholic Social Services Bureau became a member of the United Way of Cincinnati in 1955, and in 1960 the agency mission was broadened to provide counseling services to strengthen families. In 1973, the agency was challenged to 'humanize and transform the social order' through an expanded mission of 'service, advocacy and convening.' Efforts were initiated to provide emergency services and material assistance. These efforts resulted in the establishment of Welcome House, Erlanger/Elsmere United Ministries, BeCon, and others. Catholic Social Services Bureau was incorporated in 1978 and reincorporated as Catholic Charities, Inc., in 1987, at which time it included Parish Kitchen in its service array." Moser was a worker who never tired and in her early 90s was honored as the National Social Worker of the Year. She died on December 28, 1987, and is buried at St. Mary's Cemetery in Fort Mitchell. (Courtesy of Kenton County Public Library.)

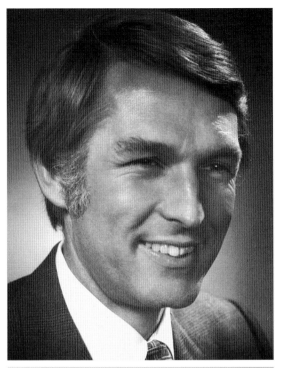

### David Harriman

David Harriman is a developer who led the redevelopment of the Covington riverfront and helped spur future projects. At the time of his efforts, Covington was suffering from many of the economic problems facing cities. He started CURE (Covington Urban Redevelopment Effort), now known as the Covington Business Council, and developed 88 condos east of the Roebling Suspension Bridge, known as Riverside Terrace and Riverside Plaza. His historic-preservation efforts have saved many Covington treasures. (Courtesy of Kenton County Public Library.)

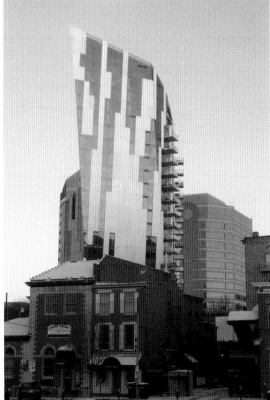

### Daniel Libeskind

Daniel Libeskind is the designer of the Ascent. The building serves as a reminder to the continued transformation of the riverfront. According to *Arch Daily*, "the Ascent at Roebling's Bridge in Covington, Kentucky, is a 20-story residential tower that was completed in 2008. Reaching 300 feet at its pinnacle, the 310,000 sqf building includes 70 residential units" and in 2008 received a CNBC Americas Property Award for Best High-Rise Development. (Courtesy of Kevin T. Kelly.)

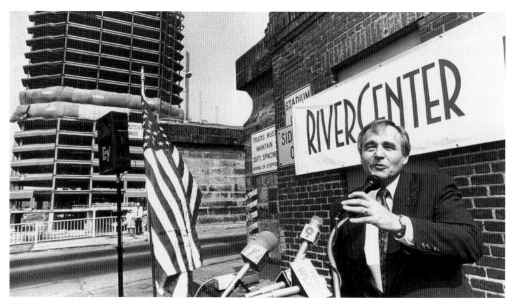

## William P. Butler

William Butler founded the Corporex Company in 1965. No other individual or company has had as profound an effect on the redevelopment of Covington as Butler and Corporex. His efforts have driven regional development in Northern Kentucky. In Covington, Butler's RiverCenter development has been a driving force behind other economic development initiatives. He is founder of the Butler Foundation and Life Learning Center, and is involved in other philanthropic endeavors. (Above, courtesy of Kenton County Public Library; below, courtesy of Kenton County Public Library.)

# CHAPTER THREE

# Political Leaders

The city of Covington has given birth to the political careers of many politicians who have had a tremendous local, state, and national impact. From the White House, to Congress, the Kentucky Supreme Court, the Kentucky Legislature, the Governor's Mansion, and the Mayor's Office, their contributions to the city of Covington are wide and varied. One individual, Bob Charles, was even elected to the Parliament of Australia. Some of these individuals are for the ages, and others are contemporary figures who are currently shaping Covington for the future. Since Mortimer Benton became the first mayor of Covington in 1834, many others have served the community. Until Sherry Carran was elected in November 2012, all had been men. One contemporary figure, Denny Bowman, is the longest-serving mayor in Covington history. Covington has had a city manager form of government for almost 90 years. It was at the forefront of modern professional city management and was one of the first communities in the nation to adopt this form of government. The individuals who have served in this office have helped lead the community through very trying times.

Throughout history, Covington and Northern Kentucky have had various degrees of influence in Kentucky politics. At times, Covington was very influential in state politics; at others, not so much. Today, presenting a regional front is more important than individual cities advocating an agenda in Frankfort, the state capital.

As they say, "all politics is local," and most of the individuals highlighted in this chapter began their careers in Covington. They worked their way up from one of the many neighborhoods and eventually served in some office. Still others were born in Covington, moved, and went on to state or national prominence. Either way, a person's home town usually has a unique place in his or her heart. As such, Covington has played some part in the accomplishments these individuals have made to their city, state, and nation.

## Orie Soloman Ware

Orie Soloman Ware was born in Peach Grove, Kentucky, on May 11, 1882, attended public schools in Covington, and graduated from a private academy in Independence operated by Prof. George W. Dunlap. Ware also graduated from the University of Cincinnati Law School in 1903 and was admitted to the bar. Ware set up his law practice in Covington. According to the *Encyclopedia of Northern Kentucky*, at the time of his death in 1974, Ware's 71 years made him the longest-practicing attorney in Covington.

Ware became active in politics, first serving as postmaster of Covington from 1914 to 1921. The appointment to this position was made by Pres. Woodrow Wilson. Ware would resign the position in 1921 to run for and win the position of Kenton County commonwealth attorney. During this time, he enforced a ban on dog racing in the county and argued a case on the issue before the Supreme Court. Taking his political ambitions to another level, he ran for the US House of Representatives in 1926 and in the primary defeated future Congressman Brent Spence. He would serve one term in the 70th Congress from 1927 to 1929. Following his Congressional career, Ware served as a federal magistrate from 1942 to 1947 and Kenton County circuit judge from 1957 to 1958. He was always very active in the community. The various hospitals in the area were near and dear to him as he worked on various campaigns to raise funds to build facilities. During World War II, he was executive secretary of the Kenton Council of Defense and chairman of the War Stamp Drive. Active in the chamber of commerce, he was awarded its first Frontiersman's Award. For almost 40 years, he was a director of the First National Bank and Trust Company of Covington. Ware died in Fort Mitchell, Kentucky, on December 16, 1974, and is buried in Highland Cemetery. (Courtesy of Kenton County Public Library.)

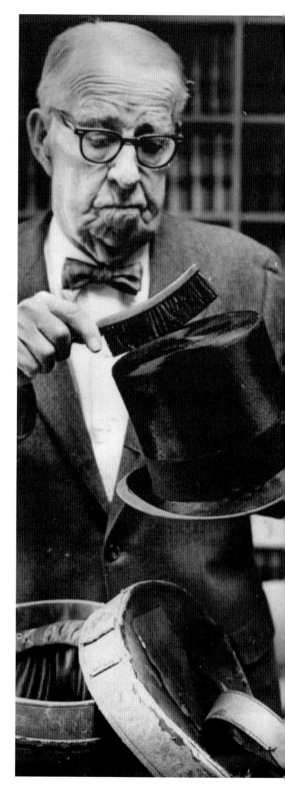

**William Wright Southgate**
William Wright Southgate was a member of the US House of Representatives, elected as a Whig, and served in Twenty-fifth Congress from 1837 to 1839. He was educated in private schools and with private tutors, and graduated from Transylvania College in Lexington. While born in Newport, he moved to Covington and was admitted to the bar. Southgate served 12 years in the Kentucky House of Representatives. (Courtesy of Kenton County Public Library.)

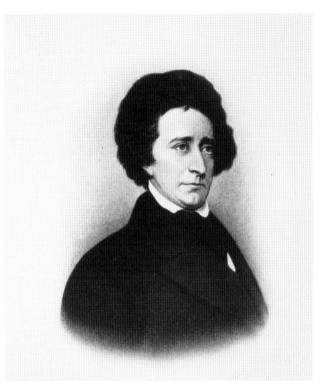

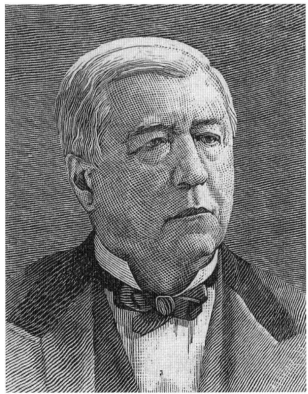

**John W. Stevenson**
John W. Stevenson was a Democratic politician who served as the 25th governor of the state of Kentucky. He moved to Covington in 1941 and soon began his political career, being elected to the Kentucky House of Representatives. Eventually he would serve as Kentucky lieutenant governor, governor, and as a US congressman and senator. Stevenson died at the age of 73 and is buried in Spring Grove Cemetery in Cincinnati. (Courtesy of NKY Views.)

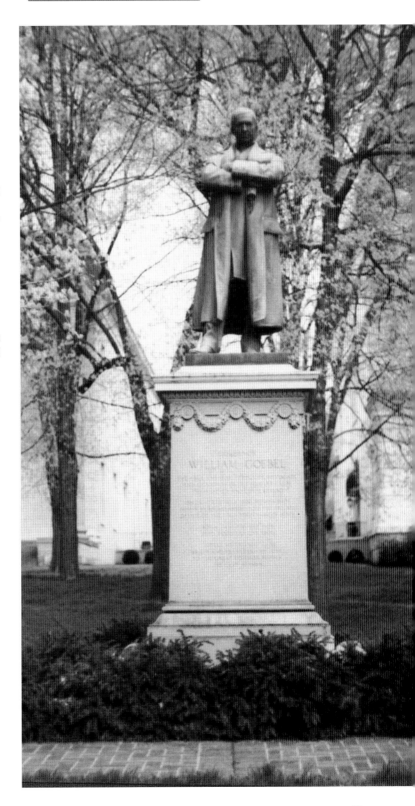

**William Goebel**

(OPPOSITE PAGE AND RIGHT) William Goebel was born January 4, 1856, and served as Kentucky governor. His term of office spanned only a few days as the result of an assassination attempt before being sworn into office. He died shortly thereafter on February 3, 1900, and currently is the only governor to die from assassination while in office in the history of the United States. Goebel is currently the last governor of the state to be from Northern Kentucky. He had a strong, some say abusive, personality but was a populist politician whose causes included railroad regulation. This cause led to great political upheaval in the state of Kentucky and led directly to his assassination. He defeated Republican William S. Taylor in a close election. Goebel was governor for three days and died at the age of 44. He is buried in the Frankfort Cemetery. (Both, courtesy of Kenton County Public Library.)

### Richard P. Ernst

Richard P. Ernst, born in Covington on February 28, 1858, was a lawyer and politician. He served on the Covington City Council from 1888 to 1892. A graduate of the University of Cincinnati Law School, he was elected to the US Senate and served from 1921 to 1927. He lost his bid for reelection. Ernst is the namesake of Camp Ernst in Boone County. He died in 1934 and is buried at Highland Cemetery in Fort Mitchell. (Courtesy of Kenton County Public Library.)

### Joseph L. Rhinock

Joseph L Rhinock moved from Owensboro to Covington at the age of seven. Elected at age 30, he is the youngest mayor in Covington's history. Rhinock would later be elected to the US House of Representatives. He served three terms from 1905 to 1911. Following his political career, Rhinock held various positions in the Shubert Theatre Corporation and later served as vice president of Loew's Theatres. He died in 1926 and is buried at Highland Cemetery. (Courtesy of Kenton County Public Library.)

**Harvey Myers Jr.**
Harvey Myers was born in Covington in 1859 and became a prominent lawyer. He was a charter member of the Kenton County Bar Association. Myers served in the Kentucky House of Representatives from 1886 until 1890. Despite this short time, he became Kentucky's speaker of the house. Myers practiced law until his death in 1933. He organized Twin Oaks Country Club in 1927 and was a leader of the Latonia Jockey Club. (Courtesy of Kenton County Public Library.)

JOHN W FINNELL
BRIG GEN
ADJ GEN
KY STATE TROOPS
DEC 24 1821
JAN 25 1888

**John Finnell**
John Finnell, a Kentucky adjutant general during the Civil War, also served as Kentucky secretary of state. In 1856, he served as legal counsel for Archibald Gaines, whose slave Margaret Garner murdered her two-year-old daughter during a failed attempt to gain the family's freedom. Finnell served in the Kentucky Legislature from Nicholas County and later practiced law in Covington. He died in 1888 and is buried in Linden Grove Cemetery. (Courtesy of Kenton County Public Library.)

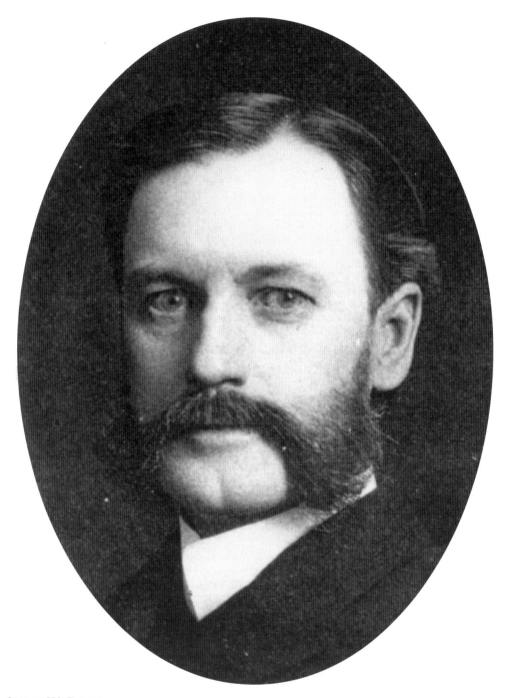

**James W. Bryan**

James W. Bryan was born in Millersburg, Kentucky in 1852 and moved to Covington to study law. He served as Kentucky lieutenant governor from 1887 to 1891 under Gov. Simon G. Buckner. To that point in time, Bryan was the youngest person ever elected lieutenant governor. Prior to his term as lieutenant governor, Bryan was a Kentucky state senator. He died in Covington on April 7, 1903, and is buried in Highland Cemetery. (Courtesy of Kenton County Public Library.)

## Maurice Galvin

According to the *Encyclopedia of Northern Kentucky*, Maurice Galvin was one of the "most powerful Kentucky Republican political bosses and powerbrokers of the 20th century." He worked closely with Kentucky governors—whether Republican or Democrat—from 1900 until the late 1930s. A workaholic, he was attorney for many prominent organizations in Covington. He died in 1940 at the age of 68. (Courtesy of Kenton County Public Library.)

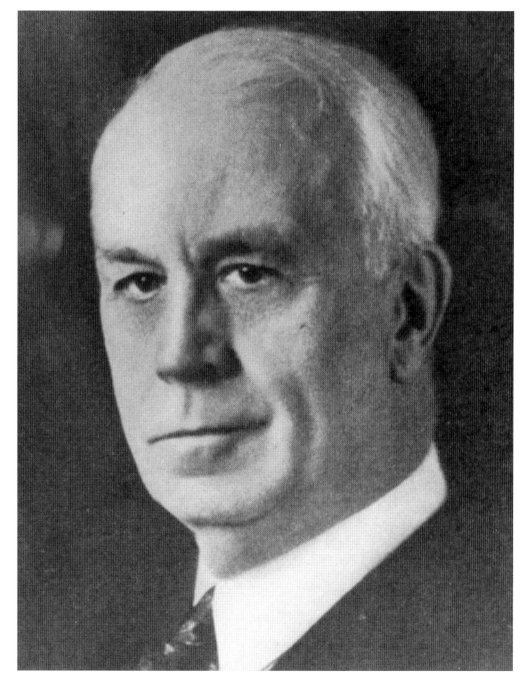

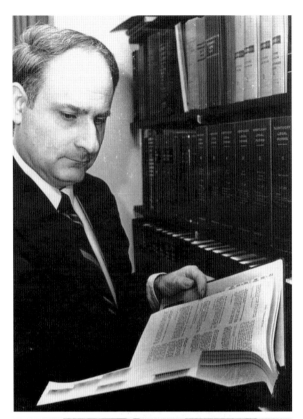

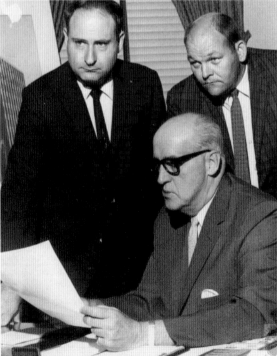

### Donald Wintersheimer

Donald Wintersheimer, born April 21, 1931, in Covington, would become one of the region's most visible and prominent legal minds. He obtained his JD from the University of Cincinnati Law School, was a private attorney, and served for 14 years as the solicitor for the City of Covington. Wintersheimer was elected in 1976 to the Kentucky Court of Appeals and in 1982 to the Kentucky Supreme Court. In his book *Secrets of the Kentucky Supreme Court*, Wintersheimer describes his approach to the bench: "Each particular case is important and entitled to dignity and respect. There is little or no room for humor; sarcasm, or impatience on the part of a judicial officer. Judges and justices at every level deal with very serious matters that directly impact the lives, liberty and property of individual human beings." He retired from the bench in 2006. (Both, courtesy of Kenton County Public Library.)

**Gary Bauer**

Gary Bauer was born in Covington, Kentucky, on May 4, 1946, and is a national political figure and former presidential candidate. He grew up in Newport and graduated from Newport High School. Bauer received his bachelor's degree from Georgetown College in Kentucky and his law degree from Georgetown University in Washington, DC. While attending law school, Bauer worked for the Republican National Committee as an assistant director of research He served under President Reagan as secretary of planning and budget in the Department of Education and as chairman of Reagan's Special Working Group on the Family, which issued the report "The Family: Preserving America's Future." Bauer is well known for serving as president of the Family Research Council from 1988 to 1999, before resigning to run for the presidency. Bauer announced his run for the Oval Office on April 21, 1999, at Newport High School. He dropped out of the election during the primary season. He received eight percent of the vote in the 2000 Iowa caucuses but only one percent during the next contest, the New Hampshire primary. A strong pro-life advocate, Bauer has worked on pro-family and pro-life issues. He continues to champion conservative causes and is one of the most visible faces for the positions he advocates. Bauer is a signer of the Manhattan Declaration: A Call of Christian Conscience, an ecumenical statement "calling on evangelical, Catholic and Orthodox Christians not to comply with rules and laws which they claim would compel participation in or blessing of abortion, same-sex marriage and other matters that go against their religious consciences" Currently, Bauer serves as president of America Values, which, according to its website, is a nonprofit organization "committed to uniting the American people around the vision of our Founding Fathers." He lives in Virginia with his wife, Carol. (Courtesy of Kenton County Public Library.)

## Gus Sheehan

Gus Sheehan was a longtime Kentucky legislator and newspaper publisher. Born in Covington in 1917, he would serve for two terms in the Kentucky House of Representatives and for 16 years as a senator. At the age of 18, Sheehan started his own paper, the *Ludlow News Enterprise*, which he would continue to publish for 32 years. Sheehan died at the age of 83 on October 30, 2000. (Above, courtesy of Kenton County Public Library; below, courtesy of Kenton County Public Library.)

## Joe Meyer

Growing up in Covington, Joe Meyer loved politics. He served in the Kentucky House of Representatives from 1982 to 1988 and as a state senator from 1989 to 1996. A strong-willed politician, he focused on education and led reform of local government pensions. Meyer served as secretary of the Kentucky Education and Workforce Development Cabinet from 2009 to 2013. (Courtesy of Kenton County Public Library.)

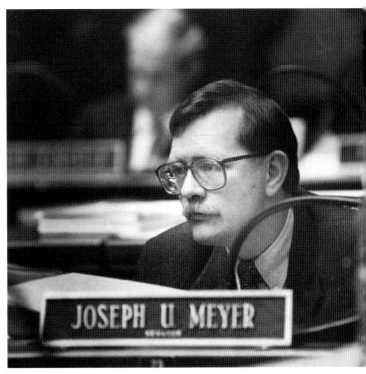

## Carl Kiger

Carl Kiger was a Covington politician in the late 1930s and early 1940s. He served on the Covington City Commission from 1936 until his death in 1943 and was one of the region's most powerful and popular political figures. He attained the office of vice mayor but is best remembered as the victim of one of the most famous murders in Northern Kentucky history. Kiger and his young son were killed by his daughter Joan, who suffered from night terrors. (Courtesy of the author.)

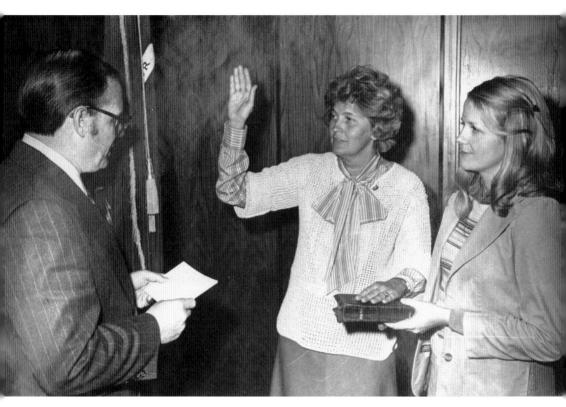

**Eulu Bingham**

Eulu Bingham was born in Covington, Kentucky, and is a scientist, having degrees from Eastern Kentucky University and the University of Cincinnati. Shown being sworn in, she served as an assistant secretary of labor for occupational safety and health during the Carter administration. Born in 1929, she also served in various other positions, including with the National Institute for Occupational Safety and Health, the Food and Drug Administration, and the Environmental Protection Agency. (Courtesy of Kenton County Public Library.)

**Former Mayors**

Six mayors are shown at the swearing-in of Mayor Ron Turner on March 16, 1987. From left to right, they are Bernie Moorman, George Wermeling, Bernard Grimm, Bernard Eicholz, Tom Beehan, and Ron Turner. Turner served the remainder of 1987, filling the uncompleted term of Beehan, who resigned. (Courtesy of Kenton County Public Library.)

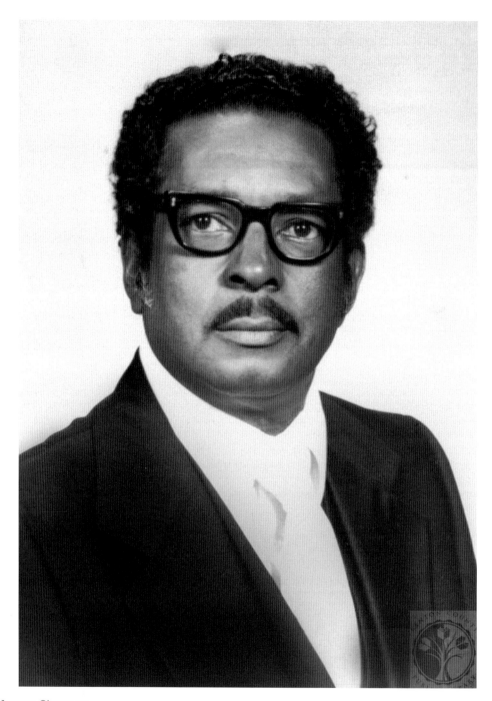

**James Simpson**
James Simpson is the first African American to be elected and serve on the Covington City Commission. He is the father of state representative Arnold Simpson. James was born in 1928 in Somerset, Kentucky, and died in Covington in 1999. He was an Army veteran and active in the community, including serving as chair of the Kenton County Airport Board and the board of Booth Memorial Hospital. (Courtesy of Kenton County Public Library.)

## Denny Bowman

Denny Bowman is one of the longest-serving mayors in Covington history. When he resigned as mayor effective September 30, 2011, he had served the city for 27 years, including 19 as an elected official. Bowman was born in 1949 and was chosen as vice mayor while serving on the city commission. He was first elected to the position of mayor in 1988 and served until 2000; he was elected to another term in 2009 and served until stepping down. Bowman, as a "strong mayor," was not a supporter of the city manager form of government. He served during some tremendous growth for the city and was widely considered a populist mayor who oversaw an expansion of social services. (Above, courtesy of Kenton County Public Library; below, courtesy of Kenton County Public Library.)

### Ron Ziegler

Ron Ziegler signs autographs on a visit to Dixie Heights High School. Ziegler was born in Covington in 1939. At college, he became active in Republican Party activities including Richard Nixon's failed attempt to become California governor. When friend H.R. Haldeman became chief of staff for President Nixon, Ziegler followed as press secretary. At the age of 29, he became the youngest press secretary in history and the first press secretary in the new White House Press Briefing Room. Ziegler was press secretary during the Watergate scandal. He was a strong defender of Nixon and appeared before Congress many times during the political crisis. According to the *New York Times*, it was Ziegler who first called Watergate a "third-rate burglary" and later admitted that his statements during the Watergate investigation had become "inoperative"—two famous quotes that stuck in popular culture. Ziegler died in 2003. (Left, courtesy of Kenton County Public Library; below, courtesy of Kenton County Public Library.)

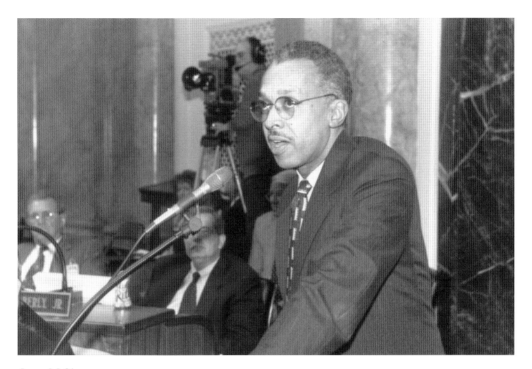

## Arnold Simpson

Arnold Simpson was born April 26, 1952, and is the son of former Covington commissioner James Simpson Jr. and his wife, Zona. In October 1986, Simpson became the first African American to serve as Covington city manager. Previously, he served for approximately six years as assistant city manager. In 1994, Simpson won a special election as a Democrat for Kentucky state representative and has been elected every term since. He is a graduate of Holmes High School and Kentucky State University, and has a law degree from the University of Kentucky. Simpson serves on the boards of many organizations in the region and has been active in the legislature in areas such as appropriations and revenue, local government, transportation, and licensing and occupations. (Above, courtesy of Kenton County Public Library; below, courtesy of Kenton County Public Library.)

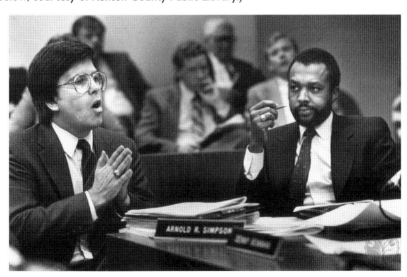

**Chuck Scheper**
Chuck Scheper became the mayor of Covington in 2011 to fill the unexpired term of Mayor Denny Bowman. He is best known for "The Scheper Report," an analysis of Covington's government with recommendations on making it more efficient. He served as mayor through 2012 and is widely respected for his accomplishments. Previously, Scheper was chief operating officer at Great American Financial Resources and currently serves chairman of the board of Bexion Pharmaceuticals. (Courtesy of Chuck Scheper.)

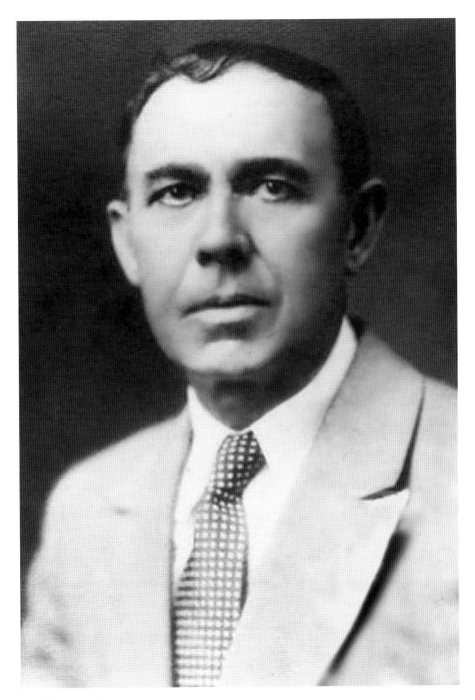

**Charles Zimmer Sr.**
Charles Zimmer was the great-grandfather of former mayor Chuck Scheper. Zimmer was born on April 5, 1868, and was elected to the city commission in 1929 on a ticket promoting the city manager form of government. The ticket won and quickly created that form of government for the City of Covington. Zimmer is also known as the founder of Zimmer Hardware, a longtime Covington business. He died on March 8, 1942. (Courtesy of Kenton County Public Library.)

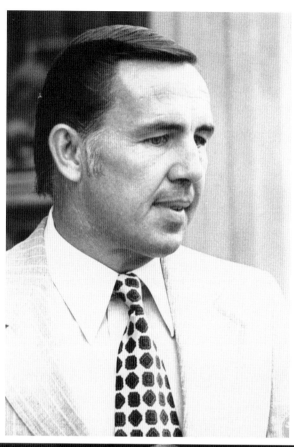

### Ken Lucas

Ken Lucas served as a member of the US House of Representatives from 1999 to 2005. As a so-called Blue Dog Democrat, he served in Kentucky's most conservative district by advocating pro-life and pro-business principles. After three terms, Lucas chose not to run for reelection, citing his promise to term-limit himself. Lucas served with tremendous distinction in the Air Force from 1955 to 1967 and later in the Air National Guard; he achieved the rank of major in the Guard. Although much of his community service and residence were in Boone County, Lucas was born in Covington on August 22, 1933. He served Boone County as judge/executive and Florence council member, among other roles. He was a highly successful financial planner and continued his service to Kentucky as commissioner of veterans affairs in the administration of Gov. Steven Beshear. (Left, courtesy of Kenton County Public Library; below, courtesy of Kenton County Public Library.)

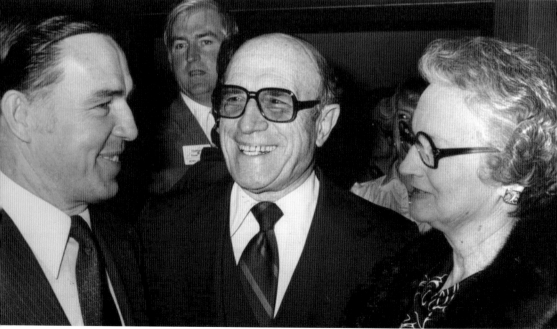

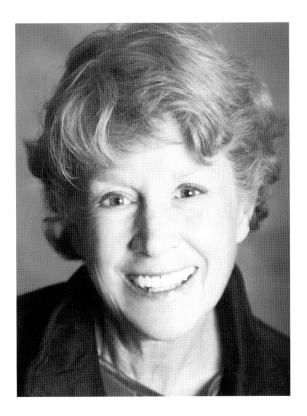

**Sherry Carran**

Sherry Carran was elected to the position of mayor of Covington in November 2012 and began her historic term in January 2013. Carran is the 41st mayor of Covington and is the first female to hold the position. Prior to being elected mayor, she served six years as a city commissioner. Carran has had a long history of volunteerism in the city and was named by the Northern Kentucky Area Development District as its Outstanding Volunteer of the Year for 2006. According to her City of Covington official biography, she has been active in "the Hope VI Project to replace Jacob Price Housing, beginning with the planning meetings in late-2008 for the HUD Application that was awarded $17 million, up to and including the steering committee that concluded in late-2011 with the plans for the redevelopment project called River's Edge at Eastside Pointe; the Neighborhood Stabilization Program that brought $5 million to the city for rehabbing blighted and vacant properties; Covington's Riverfront Commons master planning; and Vision 2015's Licking River Greenway, from the master planning to the current working committee for implementation and volunteer days working on the trails. Mayor Carran also serves on the following: the Kenton County Governance Study Group; the Brent Spence Bridge Replacement Project's Aesthetics Committee; the Green Umbrella; Northern Kentucky Urban & Community Forestry Council; and the Banklick Watershed Council."

Carran considers herself first and foremost as a community activist and as mayor still considers this her role. Carran is known for a passion for Covington. According to Mark Neikirk, director of Northern Kentucky University's Scripps Howard Center for Civic Engagement, "she's interacted with a lot of people, and built credibility through a quiet, passionate, thoughtful model of leadership." She worked hard in various neighborhoods of Covington while at the same time taking a regional approach to problem-solving and government cooperation. In addition, as a volunteer and as mayor, Carran believes in beautification projects and aims to manage and expand the green space in Covington. In addition to the being awarded the volunteer award, she was named as one of the Outstanding Women of Northern Kentucky in 2008, and was named by the Kentucky Society of Architects as a John Russell Groves Citizens Laureate in 2010. (Courtesy of Sherry Carran.)

**Larry Klein**

Larry Klein was appointed city manager of Covington in July 2009 and previously served as the city's assistant city manager. Prior to joining Covington, he served as city administrator of Fort Wright from 1998 to 2008. Klein also spent approximately 10 years in the treasurer's office of the Kenton County Fiscal Court. He holds a master's degree in public administration. (Courtesy of Larry Klein.)

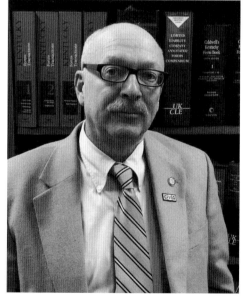

**Frank Warnock**

Frank Warnock is the assistant city manager for administration and the city solicitor for the City of Covington and a graduate of Salmon P. Chase College of Law. He serves as chair for the Northern Kentucky Bar Association Local Government Committee and as solicitor is responsible for handling all claims and legal matters before the city. (Courtesy of Frank Warnock.)

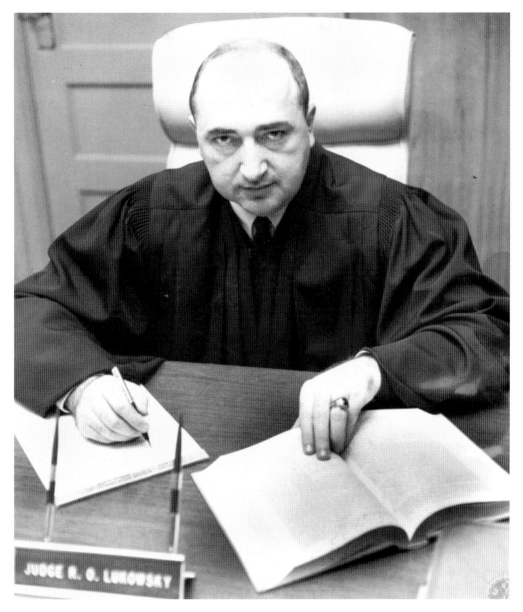

**Robert O. Lukowsky**
Robert O. Lukowsky was born in Covington on August 23, 1927, and has served as a highly respected and acclaimed judge and legal writer. He served as a circuit judge before being elected to Kentucky's highest court at the time, the Court of Appeals. He led efforts in Kentucky for judicial reform dramatically altering the organization of Kentucky's judicial system, including creation of the Kentucky Supreme Court in 1975. Lukowsky passed away in 1981. (Courtesy of Kenton County Public Library.)

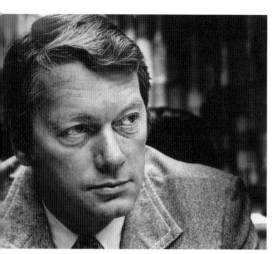
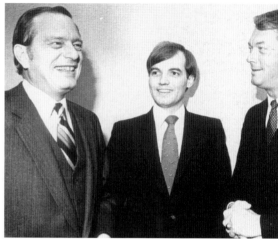

## Jim Bunning

Jim Bunning was born in Covington, Kentucky, on October 23, 1931, and attended Xavier University, where he obtained his degree in economics. Bunning is shown above with former US representative Guy Vanderjagt and former state representative Barry Caldwell. Bunning was drafted by the Detroit Tigers and would go on to a Hall-of-Fame baseball career, during which he won 224 games and struck out 2,855 batters. Following his retirement from baseball, Bunning would enter politics as a Fort Thomas City Council member. Bunning would be elected to the Kentucky State Senate two years later and was an unsuccessful candidate for governor in 1983. Bunning served in the US House of Representatives from 1987 to 1999 and was then elected for two terms to the US Senate. Bunning is married to the former Mary Theis, and they have nine children and many grandchildren. (Above, courtesy of Kenton County Public Library; below, courtesy of Kenton County Public Library.)

### Brent Spence

A native of Newport, Kentucky, Brent Spence had a tremendous impact on Covington. Born in 1874, he attended the University of Cincinnati Law School. Spence served in the Kentucky Senate from 1904 to 1908 and was Newport city solicitor from 1w916 to 1924. In 1928, he ran for US Representative but lost, only to win the seat two years later. Spence would continue to serve for 16 terms. He was chairman of House Banking and Currency Committee and instrumental in getting the Internal Revenue Service Center located in Covington. Spence also obtained funding for the Greater Cincinnati/Northern Kentucky Airport and floodwalls along the Ohio River. He retired from the House in 1963 and the new I-75 Bridge in Covington was named in his honor. Spence died in 1967 at the age of 88 and is buried in Evergreen Cemetery in Southgate. (Left, courtesy of Kenton County Public Library; below photograph by Ray Hadorn, courtesy of Kenton County Public Library.)

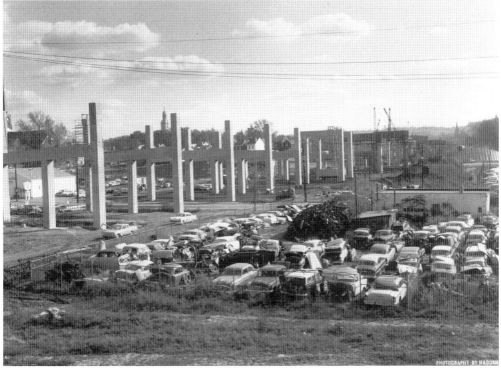

51

**Robert F. Stephens**
Robert F. Stephens was born in Covington and became a justice on the Kentucky Supreme Court. Prior to serving on the supreme court, Stephens was attorney general of Kentucky from 1975 to 1979. Stephens was appointed by Governor Carroll (left above) to fill an unexpired term on the court and continued to serve until 1999. Stephens died of lung cancer on April 13, 2002, and is buried in the Lexington Cemetery. (Courtesy of Kenton County Public Library.)

# CHAPTER FOUR

# Business, Church Leaders, and Professionals

No community can achieve any kind of success or growth without its business and church sectors. The professionals who make up the leadership of the businesses and churches in Covington have helped define the fabric of the community. They are in many ways the heart and soul of the city and have grown the community since its founding 200 years ago. When Covington was first envisioned as a city it was farmland, but it quickly grew to include manufacturing and other businesses. As people migrated to the new community on the banks of the Ohio River, churches sprang up and still to this day dominate much of the skyline. The Christian Church (Disciples of Christ), the Roman Catholic Church, and many others set up shop in the growing community. With good jobs and a good infrastructure of business, churches, and transportation, the community grew. Population steadily increased, and Covington survived depressions, health epidemics, and floods to remain strong. However, institutions are merely buildings without the people who made them what they are. Highlighted in this chapter are many individuals from all walks of life who to this day continue to make Covington a community on the rise. Yes, Covington has had many problems over the years and continues to be plagued by common urban problems facing so many American cities. However, without so many professionals and outstanding people Covington would not have succeeded over the past 200 years, and as can be seen in this chapter, the tradition continues. Over the last century many people in Covington have created successful business and churches; and so many of them have had impacts well beyond the boundaries of the city. Covington was once the retail hub of Northern Kentucky, with great local businesses. It also is the home to many individuals who have conducted charity work. Covington citizens are, without a doubt, among the most caring in the region, performing many of the services that make a difference in the lives of so many. It is this kind of history and caring, established by great people, which is profiled here. There are many more who have made a difference, and the individuals in this chapter are just a few. However, they are examples of the kind of outstanding contributions Covington has made to the business and faith-based sectors of the city and region.

**Simon Watkins**

Simon Watkins was the first African American physician in Covington. Born in Alabama in 1868, he died in Covington in 1948. Watkins was not just a physician but a surgeon and dentist as well. In 1912, he organized the Medical Society of Colored Physicians, Surgeons, Dentists, and Pharmacists in Covington, according to the *Encyclopedia of Northern Kentucky*. Watkins is buried in Linden Grove Cemetery in Covington. (Courtesy Linden Grove Cemetery.)

**Jesse Root Grant and Hannah Simpson**

Jesse Root Grant and Hannah Simpson were the parents of Pres. Ulysses Grant. Jesse was born in 1794 in Pennsylvania and died in Covington in 1873. Hannah married Jesse at the age of 27 in 1821 and the following year, the future Civil War general and president of the United States was born. Hannah died in 1883. Pictured is the Jesse Root Grant House on Greenup Street. (Courtesy of Kevin T. Kelly.)

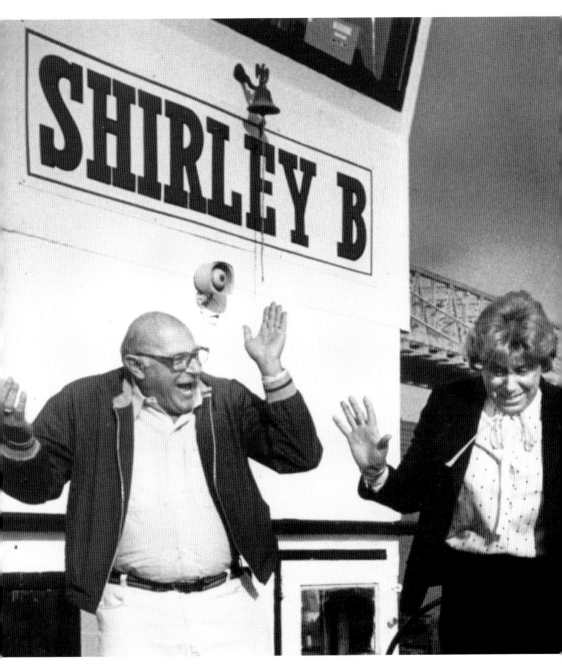

**Ben Bernstein**
Ben Bernstein was born January 25, 1921, and died January 27, 1992. Bernstein was a famous Northern Kentucky restaurateur. He bought the Mike Fink Restaurant in 1976 and started Northern Kentucky's first floating restaurant. He was the founder of BB Riverboats, a business still successful and important along the riverfront. Bernstein is buried in Spring Grove Cemetery in Cincinnati. (Courtesy of Kenton County Public Library.)

**Ralph Haile**
(RIGHT AND OPPOSITE PAGE)
Ralph was a well-respected banker in Covington. Born and raised in Cincinnati, Haile served in World War II as a pilot. He spent 19 years as chief executive of Peoples Liberty and Trust Company in Covington and more than anything was well known—along with his wife, Carol—for both generosity and support of the city. According to their foundation webpage, "Carol and Ralph established their Foundation to facilitate their annual giving. But they also wanted the Foundation to be the steward of their wealth, to ensure the funds would be used to improve the communities they loved and cherished. Upon Ralph's death in 2006, the Foundation was funded by his estate and we began our journey of developing funding strategies that align with the Hailes' passions in four areas: Arts and Culture, Community Development, Education, and Human Services." (Opposite page, courtesy of Kenton County Public Library; right, courtesy of Kenton County Public Library.)

**Clay Wade Bailey**

Clay Wade Bailey has been called the "dean of Kentucky journalists" and covered politics for the *Kentucky Post* starting in 1938. His career spanned 46 years. As Sen. Wendell Ford said (in a quote gathered by Jim Reis), "Without a doubt, Clay Wade Bailey was one of the most unusual reporters in Frankfort. He was a walking repository of knowledge." He died in 1974 before seeing completion of the Ohio River Bridge named in his honor. (Right, courtesy of Kenton County Public Library; below, courtesy of Kenton County Public Library.)

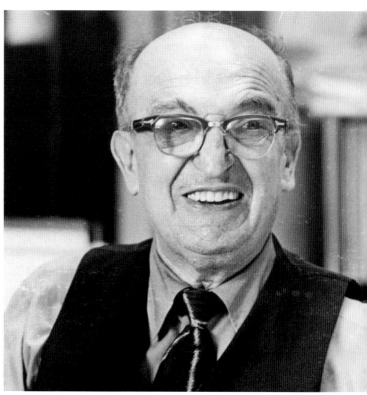

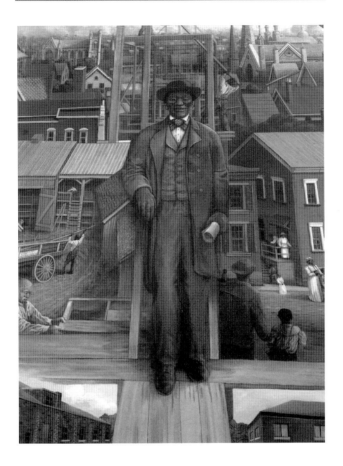

## Jacob Price

Jacob Price was born in Woodford County, Kentucky, in 1839 and died in Covington in 1923. Price was a well-respected leader of the African American community. He served as minister of the First Baptist Church and later played a significant role in founding the Ninth Street Methodist Episcopal Church. He founded the First Baptist Church in Covington and the first private school for African Americans. As a businessman, he operated a lumberyard and is the namesake of the Jacob Price Housing complex in Covington. The *Encyclopedia of Northern Kentucky* reports Price was a freeman before the end of the Civil War and is listed in the 1860 census as a laborer and a minister of the gospel. Slavery remained legal in Kentucky until after the end of the Civil War when the 13th Amendment was ratified. The census also indicates that Price could read and write, which would have been unusual for a black man of the times. In total, Price was a businessman, advocate for education rights, and active in politics and civic affairs. An advertisement for his lumberyard in 1882, according to Jim Reis, reads as follows: "Headquarters for lumber. Jacob Price dealer in all kinds of rough and dressed lumber, shingles, lath, locust and cedar posts." The lumberyard continued in operation until around 1914. Price's political savvy and his relationship with William L. Grant helped lead to the establishment of an African American school. It was located at Seventh Street and eventually was named the William Grant High School and opened in 1880. It was because of smart political decisions, or just backing the right candidate, by Price and Isaac Black, that this school became a reality. According to Jim Reis in *Pieces of the Past 2*, in a 1929 account, Samuel Singer writes about a meeting between Grant, Black, Price, and two others: Grant "made his proposition to them: that if Colored voters would support him as a candidate to the legislature and if elected, he would have the Charter of Covington amended so as to provide for a public school for Colored children." Price, while pressured to support a Republican, backed Grant, a Democrat. Price is buried in Evergreen Cemetery in Southgate. (Courtesy of Kevin T. Kelly.)

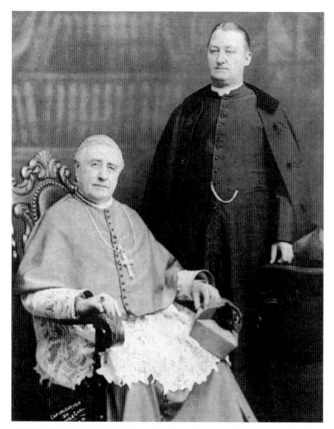

**Comillus Paul Maes**
Commillus Paul Maes served as Covington bishop from 1885 until 1915. Born in Belgium in 1846, Maes oversaw the construction of the Cathedral of the Assumption. The beauty and artistry of the cathedral can be directly attributed to Bishop Maes's interest and studies in architecture. Maes oversaw many church construction projects and had a strong interest in Appalachian and African American education. Mayes died on May 11, 1915, and is buried at St. Mary's Cemetery in Fort Mitchell. (Both, courtesy of Dioceses of Covington.)

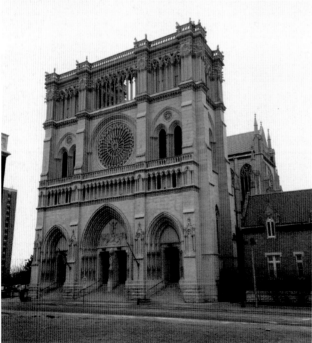

## James Bradley

James Bradley was born around 1800 in Africa and taken as a slave to South Carolina. He was sold to the Bradley Planation in Pendleton County, Kentucky, and did odd jobs at night for other plantations. With the money Bradley bought his freedom. He made his way to Covington and crossed to Cincinnati and became active in the abolitionist movement. The statue of Bradley on the Covington riverfront is approximately where he crossed. (Courtesy of Kevin T. Kelly.)

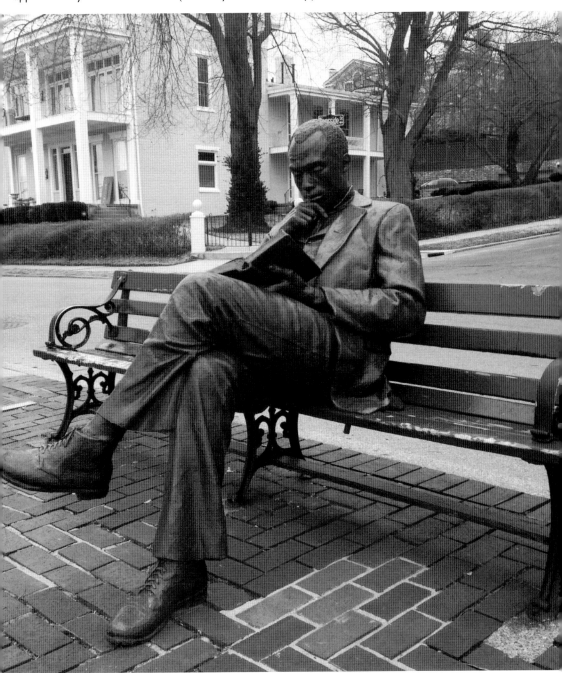

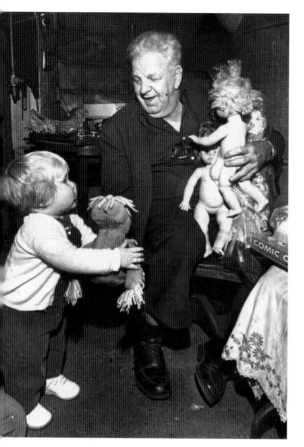 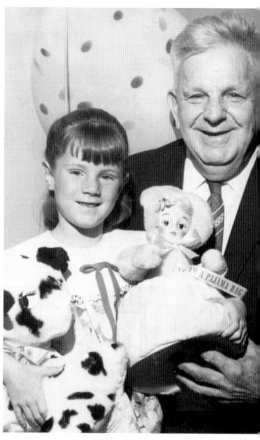

## George Steinford

George and Rose Steinford were married in 1923 and almost immediately began repairing and buying toys for the underprivileged of Covington. This effort became their life's passion and, while George died in 1980 and Rose in 1973, their impact continues to be felt today. According to the Steinford Toy Foundation, "Toys are purchased through donations from the Foundation's fundraising activities as well as toy donations from area businesses that help coordinate toy drives each year." It is estimated over 2,000 children in Northern Kentucky receive presents from the foundation each year. The Steinfords were married for 50 years and are buried in Mother of God Cemetery in Latonia. (Left, courtesy of Kenton County Public Library; right, courtesy of Kenton County Public Library.)

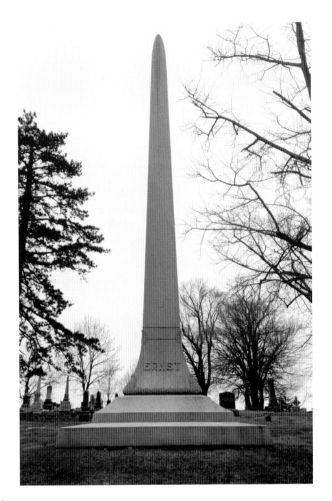

## James C. Ernst

James C. Ernst was born in Covington in 1855 and was a very successful banker and transportation executive. Ernst graduated from Princeton University in 1873. According to the *Encyclopedia of Northern Kentucky*, Ernst was a gifted athlete and a very successful baseball player. He excelled at baseball and many professional teams made him offers, but he returned to Covington, where he became head cashier with the National Bank of Kentucky. He remained there until accepting a position with the Kentucky Central Railroad. In 1876, he founded a semiprofessional baseball team, the Covington Stars, and built a ballpark for them to play. Ernst left Kentucky Central Railroad and went back to banking as president of German National Bank, a position he held for 21 years. However, in 1896, he, along with his brother and others, purchased the Cincinnati, Newport & Covington Railway Company, which included the Rosedale Electric Company. James was made president of both companies. His tremendous business mind led him to sell excess electricity generated by the railroad to businesses and residential customers. By the turn of the century, he had formed the Union Light and Power Company (ULHPC) and became its president. The railroad company and ULHPC were sold to Northern American Company and still later to Columbia Gas and Electric. In both cases, Ernst was asked to stay on to run the companies. The Cincinnati, Newport & Covington Railway Company also owned the Greenline Company and its electric streetcar line. Ernst saw the expansion of the line all the way to Fort Mitchell. A tremendous business executive operating a vast network of companies, he retired in 1914 to North Carolina because of bad health. Ernst died on September 20, 1917, and is buried in Highland Cemetery in Fort Mitchell. His beautiful monument stands tall in the cemetery. (Courtesy of Kevin T. Kelly.)

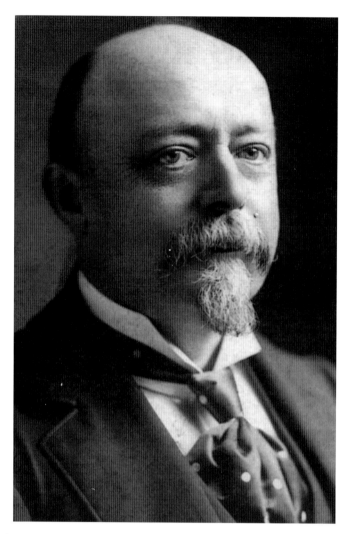

**John R. Coppin**

John R. Coppin was born on December 24, 1848, in Cincinnati and died December 21, 1913. During his life, he became a very successful department store owner and helped define Covington as the retail center for Northern Kentucky for much of the 20th century. Coppin first worked for the H.S. Pogue Department Store in Cincinnati, before opening his own dry goods shop in Covington. His new store was called the California Dry Goods Company. The company continued to grow and space was always limited, necessitating expansion. It officially became the John R. Coppin's company on September 21, 1907, and a new seven-story building was completed by 1910. Coppin died of a cerebral hemorrhage while riding in a car in 1913. He is buried in Spring Grove Cemetery in Cincinnati. While nobody by the name of Coppin owned the store after 1923, the business started by John R. remains one of the most endearing and famous from the heyday of Covington's vibrant economic times. It was particularly successful during the 1940s and through the 1960s. Florence Mall had a terrible impact on Covington businesses—especially Coppins Department Store. The mall opened in 1976 and Coppin's was out of business shortly thereafter. Thus ended a time spanning back to the mid-19th century and into the mid-1970s, during which Covington was a vibrant district of department stores, shops, movie theaters, and anything else Northern Kentuckians wanted or needed. The majority of outsiders came to Covington to shop—and now it was nearly all gone. (Courtesy of Kenton County Public Library.)

### Ralph Drees

Ralph Drees was born in Covington, Kentucky, on April 17, 1934, to German immigrants Theodore and Elizabeth Drees. His father began a small home-builders company in 1928, and Ralph joined in 1959, after serving in the Army. A partnership was created between Ralph, his brother Richard, and their father to form the Drees Builders and Developers. In 1967, the partnership dissolved and Ralph started Drees Builders and Developers, Inc. Today, Drees Homes is the nation's 22nd-largest home-builder. Ralph has been involved in community affairs including stints as an elected official. He was elected to the Erlanger City Council in 1965 and in 2004 became judge/executive of Kenton County. Drees and his wife, Irma, have five children. Drees has long been a humanitarian and in 2006 was awarded the national Hearthstone/Builder Humanitarian Award. According to the National Association of Home Builders, "This prestigious philanthropic honor recognizes individuals who have demonstrated a lifetime commitment to helping people in the communities in which they live." (Above, courtesy of Kenton County Public Library; right, courtesy of Kenton County Public Library.)

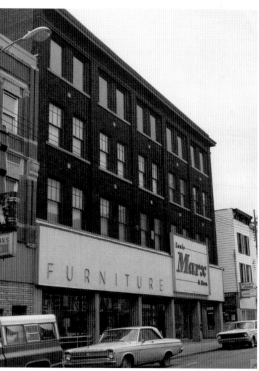

## Louis Marx

Louis Marx was a furniture businessman who owned Louis Marx and Brothers Furniture Store, a Covington staple from 1896 until the late 1980s. In 1926, Louis Marx had 20 furniture stores. Before moving to Covington, the Marx Brothers Furniture Store started in Newport in 1888. As with many other famous stores in the Covington commercial district, the name Marx is synonymous with Covington retail and the heyday of the 1940s to 1970s. (Courtesy of Kenton County Public Library.)

## Mary Magdalen Schrage

Mary Magdalen Schrage was born March 31, 1889, in Covington. Her acts of kindness during World War II brought local Northern Kentucky news to the soldiers. Every week without fail, Schrage would write to the soldiers from the area and send them the *Ludlow News Enterprise*. The local news and the kindness became the stories of legends, as soldiers recalled for years how much it helped them in faraway places stay connected to their hometowns. (Courtesy of Kenton County Public Library.)

### Alvin Poweleit

Alvin Poweleit was born in Newport, Kentucky, on June 8, 1908, and was a graduate of the University of Louisville Medical School. While in school, he enlisted in the Army Reserve and in 1941 found himself in the Pacific theater. He had been assigned to the newly formed medical detachment of the 192nd Tank Battalion. In the Philippines, Poweleit became the first American medical officer decorated for combat valor. Later, he was a prisoner of war from 1942 to 1945 and survived the Bataan Death March. As a hero, Poweleit returned to Kentucky following the war, went to school, and became a doctor specializing in eye, ear, nose, and throat. He opened his practice in Covington and worked there until he retired in 1987. He remained active in the community. Poweleit died as the result of complications from an automobile accident in 1997. (Left, courtesy of Kenton County Public Library; below, courtesy of Kenton County Public Library.)

## Margaret Garner

Margaret Garner was a slave before the Civil War and is well known for killing her own daughter instead of allowing her to return to slavery. Garner, her husband, Robert, and her children were owned by the Gaines family in Boone County, Kentucky. In January 1856, Garner and her family escaped Kentucky over the frozen Ohio River from Covington. They were captured, and Garner's defense attorney attempted to have her tried for murder in Ohio in order to have the trial held in a Free State. It was his desire to challenge the fugitive slave laws passed by Congress in 1793 and 1850. These laws call for slaves who escaped from one state into another state or territory to be returned to their owners. According to Steven Weisenburger, in *A Historical Margaret Garner*, her case was "the longest and most complicated case of its kind." Would Margaret be tried as a fugitive or murderer? The judge ruled the fugitive slave laws had "supervening" authority. Instead of murder, Garner's attorney tried to persuade the judge the fugitive slave law was unconstitutional. The argument was rejected and a trial held that gained national attention, and many people took to the streets of Cincinnati to protest. The slave laws were upheld, and the Garners were returned to Kentucky. Since she was not tried for murder, a warrant was issued for her arrest and extradition back to Ohio. She was never seen again. Their owners first moved the family around Kentucky only to later ship them off to Arkansas to their brother's plantation. It is reported, partially by Weisenburger, that in "1870 a reporter from the *Cincinnati Chronicle* found Robert Garner and gathered more about his life. Robert and Margaret Garner had worked in New Orleans, and in 1857 were sold to Judge Dewitt Clinton Bonham for plantation labor at Tennessee Landing, Mississippi. Robert said Margaret had died in 1858 of typhoid fever, in an epidemic in the valley. He said that before she died, Margaret urged him to 'never marry again in slavery,' but to live in hope of freedom." The story of Margaret Garner inspired the novel *Beloved* by Toni Morrison, a Nobel Prize winner. The book was later made into a film starring Oprah Winfrey as well as an opera composed by Richard Danielpour. (Courtesy of Kevin T. Kelly.)

### Doc Rusk

Doc Rusk was a Covington businessman and owner of Doc Rusk Heating and Air Conditioning. Originally founded as the Montgomery Coal Company, the company changed its name to the more famous Rusk in 1973—famous because Doc Rusk became a staple of the local television scene for his commercials asking customers to call the company "any time, day or night." Doc Rusk became a Northern Kentucky and Cincinnati household name. Today, Rusk is back in family hands after a purchase from Roto-Rooter and remains a longtime Covington institution. Doc, the company founder, died in 1992, but his name spurs so many memories to long-term residents. (Both, courtesy of Kenton County Public Library.)

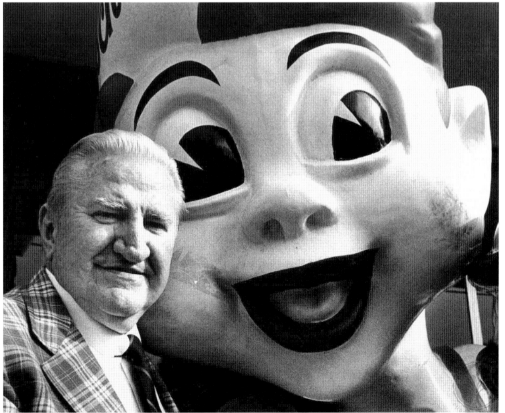

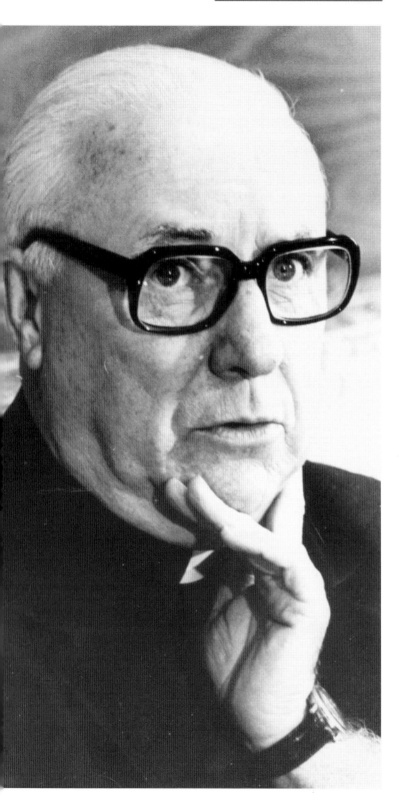

**Bishop William Hughes**
Bishop William Hughes was born in Youngstown, Ohio, in 1921 and served numerous positions in the Youngstown Diocese. He was named the eighth bishop of Covington in 1979, following the resignation of Bishop Richard Ackerman. Hughes would serve as bishop for the next 16 years, until his resignation on July 4, 1995. He passed away on February 7, 2013, and is buried in St. Mary Cemetery in Fort Mitchell, Kentucky. (Courtesy of Kenton County Public Library.)

## George Remus

George Remus was born in Germany on November 14, 1874, and was a famous Cincinnati lawyer and bootlegger during Prohibition. According to a Wikipedia entry, "Remus moved to Cincinnati, in the region of the country where 80 percent of America's bonded whiskey was located, and bought up most of the whiskey manufacturers. In less than three years Remus made $40 million, in 1920s dollars, with the help of his trusted number two man George Conners. He owned many of America's most famous distilleries, including the Fleischmann Distillery, which he bought for $197,000, a price which included 3,100 gallons of whiskey.

In addition to the Cincinnati community, many other small towns, such as Newport, Kentucky, began serving as drinking towns where gamblers opened small casinos to entertain their drunken patrons." In 1925, Remus was indicted for violation of the Volstead Act and sentenced to two years in prison and served the time in the Atlanta Federal Penitentiary. In 1927, his wife, Imogene, filed for divorce. What happened next is popular local history. According to Jeff Morris in *Haunted Cincinnati and Southwest Ohio*, "On the way to court, on October 6, 1927, for the finalization of the divorce, Remus had his driver chase the cab carrying Imogene and her daughter through Eden Park in Cincinnati, finally forcing it off the road. Remus jumped out and fatally shot Imogene in the abdomen in front of the Spring House Gazebo to the horror of park onlookers." Remus was acquitted by reason of insanity in just 19 minutes of jury deliberation. The popular Remus tried unsuccessfully to get back into bootlegging after serving six months. He retired to Covington and died at the age of 77 on January 20, 1952. He is buried in Falmouth, Kentucky. Blogslaweekly.com reports that Remus is featured in the 2011 Ken Burns documentary *Prohibition*; texts written by Remus are read by Paul Giamatti. Remus has also been portrayed by Glenn Fleshler as a supporting character on HBO's Prohibition-era series *Boardwalk Empire* since its second season. (Courtesy of NKYViews.)

### James Grimsley Arnold

James Grimsley Arnold was born in 1792 in Paris, Kentucky, and died in Covington in 1876. In 1817, he moved to Covington and was active in education and in local politics, holding several posts. A wealthy man, Arnold used his money and influences to found the First Christian Church in Covington and served as its first elder. The current church is located near Fifth Street and Madison Avenue and the parsonage is named in honor of Arnold. (Courtesy of Kevin T. Kelly.)

### Joe Wind

Joe Wind was born and raised in Covington and is vice president of government and community affairs for Northern Kentucky University. He represents the university before both the Kentucky General Assembly and Congress. Prior to joining NKU, Wind served in senior management positions with Corporex Companies Inc., Shandwick Public Relations, Northern Kentucky Chamber of Commerce, and the Kentucky Department for Employment Services. (Courtesy of Joe Wind.)

**Marvin Wischer**

Marvin Wischer serves as president of KW Mechanical, Inc., a company he created in 1987. KW has expanded many times and is a great example of a highly successful Covington business. Wisher is very active in the Covington community and serves on the boards of the Covington Business Council and the Latonia Business Association. (Courtesy of Marvin Wischer.)

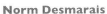

**Norm Desmarais**

Norm Desmarais is a founder of one of Covington's most innovative companies, Tier1, and serves as the chairman of its board. Desmarais is active in the Covington and Northern Kentucky community and is the head of Covington's bicentennial celebration. At Tier1, Desmarais focuses on business development, new business ventures, and community relations. (Courtesy of Norm Desmarais.)

**Richard Ackerman** (OPPOSITE PAGE AND RIGHT)
Richard Ackerman was born August 30, 1903, in Pittsburgh, Pennsylvania. He was ordained a priest in 1926 and between then and 1940 held many positions, including master of novices of the Congregation of the Holy Ghost, assistant pastor of St. Benedict the Moor Parish in Pittsburgh, assistant to the national director of the Pontifical Association of the Holy Childhood, assistant to the professor of philosophy at St. Mary Seminary in Norwalk, and assistant pastor at St. Mary Parish in Detroit, Michigan. In 1941, Ackerman was named national director of the Holy Childhood Association, and in 1947 was named the vice president of the association's superior council. In 1956, he was appointed auxiliary bishop of San Diego and on April 6, 1960, bishop of Covington. He would serve as Covington bishop until his retirement on November 28, 1978. Bishop Ackerman died on November 18, 1992, and is buried in St. Mary's Cemetery in Fort Mitchell, Kentucky. (Both, courtesy of Kenton County Public Library.)

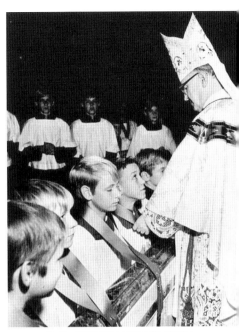

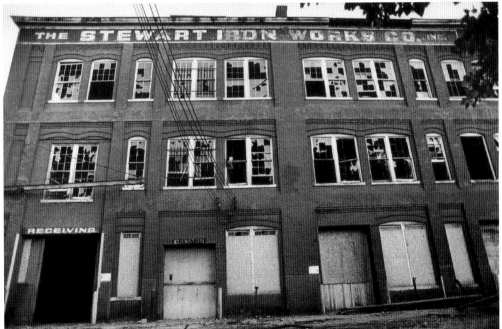

**The Stewart Family**
The Stewart family settled in Kentucky. One descendant, R.C. Stewart Sr., opened a business in Covington called Architectural Iron Works. The company made various iron products at its Madison Avenue location. Stewart's children Richard C. Jr. and Wallace A. followed their father in the ironworks industry. The two sons founded Stewart Iron Works, a very successful Covington business. The last Stewart family member's leadership of the business ended in 1955. (Courtesy of Kenton County Public Library.)

### Rick Hulefeld

Rick Hulefeld, along with his wife, founded Children, Inc. in 1979 and has served as its executive director ever since. The organization serves the needs of families and their children and is one of the region's most successful and important nonprofits. Hulefeld stands out among the many nonprofit founders in Covington for his commitment to the cause and his longtime love of Covington as a place to raise a family. (Courtesy of Rick Hulefeld.)

### Florence Tandy

Florence Tandy serves as executive director of the Northern Kentucky Community Action Commission, an eight-county human services organization with an annual budget of $12 million in federal, state, local, and private funding. She has served in this Covington based nonprofit since 2005. The commission is one of Covington's oldest nonprofits, serving low-income families with a wide range of services. (Courtesy of Florence Tandy.)

**Ray Kingsbury**
Ray Kingsbury serves as executive director of the Baker Hunt Foundation in Covington. The foundation is the legacy of Margaretta Baker Hunt, a teacher of youth and adults for many years. It has been in existence since 1922, when Baker Hunt created it "to encourage the study of art, education, and science to promote the good works of religion in Covington." The foundation is located on a 3.5-acre campus in the heart of the Licking River Historic District and includes two stately mansions, a 1920 auditorium, and studio space. (Above, courtesy of Ray Kingsbury; left, courtesy of Kevin T. Kelly.)

**William Scheyer**
Born and raised in Covington, William Scheyer is president of Vision 2015, the organization charged with implementing Northern Kentucky's 10-year strategic plan. According to Vision 2015, the plan contains specific action steps to achieve the region's goals and Northern Kentucky's future depends on the ability to work together to find creative solutions to the economic and social issues facing the region. (Courtesy of William Scheyer.)

**Geof Scanlon**
Geof Scanlon is a longtime business owner and cofounder and president of Scanlon & Associates, located in Covington. The successful company, located in the Mainstrasse area of Covington, specializes in a wide range of financial services. Geof is an example of a modern CEO making a difference in the urban core of Covington and is very active in local causes related to health and human services. (Courtesy of Geof Scanlon.)

**Charles Petty**
Charles Petty, along with his wife, Helen, took over operation of the Latonia Bakery in 1945 and helped grow one of Covington's most enjoyable and historic institutions. People lined the streets for their baked goods. Originally started in 1917, the business was operated by several owners before Petty took over. Today, the bakery continues under the name Bernhard's Bakery and has now been serving the community for almost 100 years. (Courtesy of Kenton County Public Library.)

## Warren W. Wiersbe

Warren W. Wiersbe was born on May 16, 1929, and is a writer and Bible teacher who was the pastor at Calvary Baptist Church in Covington from 1961 until 1971. His Sunday sermons were broadcast as the *Calvary Hour* on a local radio station. Wiersbe is best known as an author, and among his works is the Be series, a collection of 50 books, including *Be Real*, *Be Obedient*, *Be Mature*, *Be Joyful*, and so forth, which reportedly have sold more than four million copies. Wiersbe is also known for being a theologian and Bible scholar in the fundamental and evangelical circles. (Courtesy of Kenton County Public Library.)

## Daniel Carter Beard

Daniel Carter Beard was a social leader who founded the Sons of Daniel Boone, which later merged with the Boy Scouts of America. He was born in Cincinnati, Ohio, on June 21, 1850, and around the age of 11 moved to 322 East Third Street in Covington. Today, the home is a National Historic Landmark. Beard was a prolific writer for *St. Nicholas* magazine, the foundation for *The American Boy's Handy Book*. He illustrated books for Mark Twain and others in addition to becoming the editor of *Recreation* magazine. As he grew up on the Licking River in Covington, his life was influenced by the river in his later years. He loved young people and nature and, in 1905, founded the Sons of Daniel Boone. When it merged in 1910 with the Boy Scouts of America, Beard became the first National Scout for the Boy Scouts and served for 30 years. He served as editor of *Boys' Life* magazine, the official publication of the Boy Scouts, and wrote a monthly column. Beard also helped found the Girl Scouts of America. In 1934, he returned to Covington, and according to the *Encyclopedia of Northern Kentucky*, "he visited 2,000 Scouts camping at Devou Park in Covington." Beard died on June 11, 1941, just shy of his 91st birthday, at his home, Brooklands, in Suffern, New York. He is buried nearby in the Brick Church Cemetery. In recognition of Beard being one of Covington's most influential and famous citizens, the Daniel Carter Beard Bridge across the Ohio River was dedicated in 1981. The local administrative arm of the Boy Scouts of America is named the Dan Beard Council, and many other honors are bestowed upon his memory. Called "Uncle Dan" by so many, Beard had an influence on youth everywhere. (Courtesy of Kevin T. Kelly.)

### The Eilerman Family

The Eilerman family from Germany opened their first clothing store in Newport and founder Herman opened a second one in Covington. After moving out of the area, sons August, Benjamin, Herman Jr., and Edward took over operation of the Eilerman & Sons Men's Clothing Stores. In 1931, Benjamin and his sons obtained control of the company and it proved quite successful. The family expanded to other businesses, most notably the start of WZIP radio in Covington by Arthur Eilerman in 1947. The Eilerman family has long been engaged in civic affairs and Benjamin's grandson (Arthur's son) Chuck, is a city commissioner in Covington. As seen in the image at left, he stands as a young man with vice president Alben Barkley. In 1971, Eilerman & Sons closed due to the economic downturn in Covington. (Both, courtesy of Kenton County Public Library.)

# CHAPTER FIVE

# Entertainers, Artists, and Athletes

The city of Covington has been blessed to be the birthplace or hometown of many entertainers, artists, and athletes having a local or national influence. From the early days of movies, the birth of television, and a century of sports, Covington has provided individuals who have touched hearts, inspired through writings, given the pleasure of fine art, provided entertainment, and made people cheer. While these individuals have come from all walks of life and made their marks in various fields, one thing is certain: They had their beginning in Covington. Not only have these "stars" been famous in their careers, some have excelled. There are Hall-of-Fame members in baseball, basketball, and horse racing all from Covington. Stage actresses like Dorothy Abbott and film stars such as Una Merkel made their marks. Painters like Frank Duveneck are world renowned. Athletes like Steve Cauthen, Jim Bunning, and Dave Cowens all had their start in Covington. Each is a Hall of Famer. The city of Covington has had a long history and many of the great names of the early years are lost forever. However, during the 20th Century, names of the great entertainers are preserved through modern media and in the collective memory. The stories in this chapter provide a small glimpse into the lives of some of the most famous and influential people of the last century who at one point or another called Covington home. Some are more famous than others, but all have achieved noteworthy success in various fields. Hopefully, these brief stories will reintroduce new generations to the individuals from Covington who went onto great accomplishment in the arts and sports. Who can forget the great line in the movie *Pulp Fiction* about Covington native Durward Kirby, when the waiter dressed as Ed Sullivan asks Mia, played Uma Thurman, what she wants to eat: "I'll have the Durward Kirby burger, bloody"—and of course, a $5 shake? Perhaps more famous than anything coming out of the city is "Santa Claus is Coming to Town," the Christmas classic cowritten by Covington native Haven Gillespie.

## Steve Cauthen

(RIGHT AND OPPOSITE PAGE)

Steve Cauthen is a Hall-of-Fame jockey born in Covington on May 1, 1960. He grew up in Walton and started riding horses at an early age. By the age of 16, he had obtained his jockey license and began riding at Churchill Downs. His fame grew very quickly—despite finishing last place on his first mount. His first winner came a week into his career, with a victory at River Downs on a horse name Red Pipe. Cauthen finished the year as the leading jockey in wins at River Downs, with 120. In 1977, he led the nation in wins with 487 and became the first jockey to win $6 million in one year. He was then famously known as "the Six-Million-Dollar Man." He was named the Sports Illustrated Man of the Year in 1977, the Sporting News Sportsman of the Year, Associated Press Male Athlete of the Year, ABC Wide World of Sports Athlete of the Year, and won the Eclipse Award for Outstanding Apprentice Jockey and another for Outstanding Jockey. In 1978, his stature rose even further. Riding Affirmed, Cauthen won the Kentucky Derby and went on to win the Triple Crown. Following this success, Cauthen went to England, where he became a very famous and successful jockey and was the British champion jockey three times. He won British Classic races 10 times. After finishing his tremendous career, Cauthen returned to Kentucky, where he owns a farm in Boone County. In 1984, he was presented with the George Woolf Memorial Jockey Award and in 1994 was inducted into the Horse Racing Hall of Fame. (Both, courtesy of Kenton County Public Library.)

**Caroline Williams**
Caroline Williams was born November 10, 1908, in Covington. For almost half a century, her *A Spot in Cincinnati* sketches appeared in the *Cincinnati Enquirer.* "Caroline's sketches became extremely popular and Cincinnatians anxiously awaited the Sunday paper to see what 'nook' Caroline discovered and sketched," Susan Redman-Rengstorf writes in "The Queen City Through the Eyes of Caroline Williams," an article in the fall 1990 edition of *Queen City Heritage.* Williams died in 1988. (Courtesy of Kenton County Public Library.)

**Lee Roy Reams**
Lee Roy Reems is a Broadway actor, singer, dancer, and director. He was nominated for Tony and Drama Desk Awards as best actor for his performance in *42nd Street* in 1980. He has performed with some of the industry's best dancers and before numerous presidents of the United States. Reams was born in Covington on August 23, 1942. (Courtesy of Kenton County Public Library.)

**Kevin T. Kelly** (BELOW AND OPPOSITE PAGE)
Kevin T. Kelly, born in 1960, graduated from the Art Academy of Cincinnati in 1987 with a BFA in sculpture. He moved to New York City in 1988, where he worked as a studio assistant to Tom Wesselmann for six years. Kelly's work is described by Artistaday as "decidedly 'Neo-Pop' or 'Post-Pop" and 'Roy Lichtenstein meets Dennis Hopper on Steroids.' It's a wry, complex admixture of sardonic social commentary, the six o'clock news, and the Sunday funnies. He lives and works in Covington area." His work has appeared on the cover of *New American Paintings* in 2000 and 2003, and is featured in numerous public and private collections both in the United States and abroad, including Breitling S.A., the Kinsey Institute, and Procter & Gamble. In addition to teaching as an adjunct professor at the Art Academy of Cincinnati and the Baker-Hunt Foundation in Covington, Kelly has also written critical reviews for *Cincinnati CityBeat*, *Dialogue* magazine, *New Art Examiner*, and *AEQAI*. (Both, courtesy of Kevin T. Kelly.)

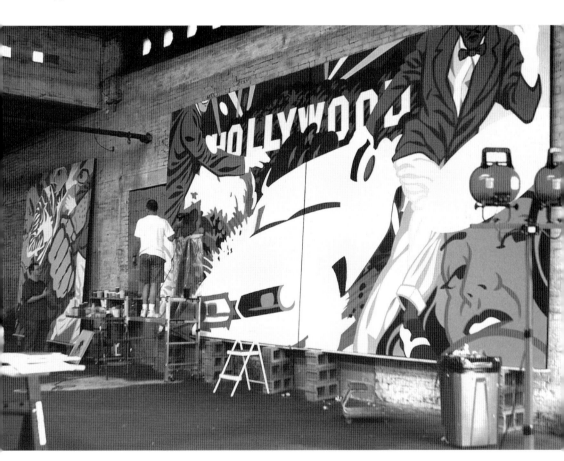

**Davis Sisters**

Skeeter Davis teamed with Betty Jack Davis, a friend at Dixie Heights High School, to form a group whose stage name was the Davis Sisters. Both attended the DeCoursey Baptist Church in Covington. They were popular on local and regional radio and had a number one hit, "I Forgot More Than You'll Ever Know." Betty was killed in an automobile accident in 1953 and Skeeter went on to a successful solo career. She died in Nashville in 2004. (Courtesy of NKYViews.)

**Ken Shields**
Ken Shields is a legendary local basketball coach at both the high school and college levels. Born in Covington in 1941, Shields served as coach of the Northern Kentucky University Norse from 1988 to 2004. He was elected to three Halls of Fame— Covington Catholic, Greater Cincinnati Basketball, and Kentucky Association of Basketball Coaches. Following the 1994–1995 season, Shields was named the National Division II Coach of the Year. (Courtesy of Kenton County Public Library.)

**Dorothy Abbott**
Dorothy Abbott was an American actress born in Covington on June 24, 1885. Her New York debut was in a play called *Within the Law*. Also a vaudeville star, Abbott played roles locally in both Covington and Cincinnati. She died of a heart attack at age 51 on April 13, 1937, in Covington and is buried at Highland Cemetery in Fort Mitchell, Kentucky. (Courtesy of Kevin T. Kelly.)

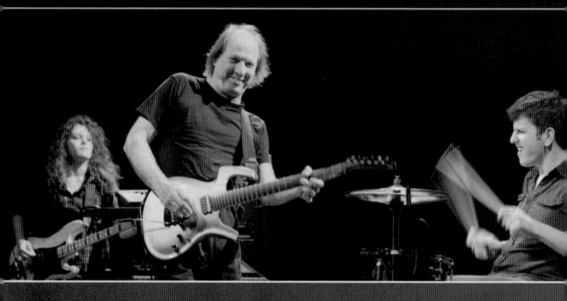

# adrian belew power trio dvd

## live in germany

**Adrian Belew**

Adrian Belew is a talented guitarist, singer, songwriter, and record producer. He was born in Covington on December 23, 1949, and played drums in the Ludlow High School Marching Band. His first band was the Denems, a Beatles cover band. In 1977, he was discovered by Frank Zappa. Belew toured with Zappa and appears on Zappa's 1979 album *Sheik Yerbouti* as well as Zappa's 1979 concert film *Baby Snakes*. While working with Zappa, he met David Bowie and joined his band, recording on the famous albums *Stage* and *Lodger*. Later, Belew toured with the Talking Heads and King Crimson. As a member of King Crimson, he performed from 1981 to 2013 and embarked on a solo career before forming a very successful group called the Bears. Over the course of his career, Belew played guitar with the likes of the Talking Heads, David Bowie, Nine Inch Nails, Laurie Anderson, and Paul Simon. He continues to perform and has had a very successful solo and band career, combined with performing regularly with superstar musicians. He is known as one of the best electric guitarists in today's music scene. (Courtesy of Adrian Belew.)

**Pat Scott**
Pat Scott was a pitcher for the All-American Professional Baseball League from 1948 to 1953. Scott was born in Covington on July 14, 1929, and raised in Burlington. She finished her career with 48 wins and 26 losses and a 2.46 earned run average. After her baseball career, she returned to the commonwealth and attended the University of Kentucky and then spent 33 years with Hamagami Labs in Cincinnati. (Courtesy of Kenton County Public Library.)

### Aileen McCarthy

Aileen McCarthy was born in Covington on September 19, 1886, and died on January 25, 1982. She was a painter and student of Frank Duveneck and taught at La Salette Academy for several years and in her home studio from 1927 to 1974. One of her students was famed artist Bernard Schmidt. In addition to being a well-respected teacher, she was also an excellent portrait artist and her painting of Duveneck is widely praised. (Courtesy of Kenton County Public Library.)

**Leo Foster**
Leo Foster went from Holmes High School to a Major League Baseball career. Foster spent five years with the Braves and Mets and made one of the more unique debuts. According to the *Hardball Times*, fielding at shortstop, he committed an error on the first ball hit to him. After flying out in the third inning, Foster hits into a double play in the fifth inning, followed by hitting into a triple play in the seventh inning. (Courtesy of Kenton County Public Library.)

**Johann Schmitt**
Johann Schmitt was born in Germany in 1825 and became one of Covington's most famous citizens of the 19th century. He specialized in painting altars and church murals, including in Mother of God Catholic Church, where he painted *Joyful Mysteries of the Rosary*. Schmitt died in Covington in 1898. His work can be found in churches all over Northern Kentucky. (Courtesy of Kenton County Public Library.)

Durward Kirby was a popular television personality born in Covington on August 24, 1911. He was best known as the sidekick on *The Garry Moore Show* during the days of live television and was cohost of *Candid Camera* from 1961 to 1966 with Allen Funt. According to Find a Grave, he was a sketch actor, singer, dancer, and pitched sponsors' products. Kirby moved to Indianapolis when he was 15, and his first radio job was at a Purdue radio station. Later radio stations included Indianapolis, Cincinnati, and Chicago. While in Cincinnati, he reported about the flood of 1937 and became nationally recognized, including for his big band broadcasts. Kirby served in World War II, and his career grew after returning and moving to New York City. Kirby was a very successful pitchman and continued to perform as an advertising announcer through many decades. In 1982, Kirby was honored to receive the Procter & Gamble Award as Outstanding Spokesman. He said, "I've done just about everything in broadcasting—covered news, special events, disasters, sports, political conventions. I've had a news commentary show, done interviews, audience participation shows, and sold products." He is a member of both the Indiana Broadcasters Hall of Fame and Greater Cincinnati Broadcasting Hall of Fame. Kirby also wrote three books—*My Life, Those Wonderful Years, Bits and Pieces of This and That*, and a children's book called *Dooley Wilson*. Kirby died of heart failure in Fort Myers, Florida, on March 15, 2000, and is buried in Coburn Cemetery in Fairfield County, Connecticut. (Courtesy of NKYViews.)

### Robert Surtees

Robert Surtees is an acclaimed cinematographer who received 16 Oscar nominations, the first for *Thirty Seconds Over Tokyo* in 1944 and the last in 1977 for *The Turning Point*. Surtees was born in Covington on August 9, 1906, and died in California on January 5, 1985. He worked on many great films, including *Ben-Hur, Oklahoma!* and *The Sting*. He won seven Academy Awards. (Courtesy of Kevin T. Kelly.)

### David Justice

David Justice attended Covington Latin School and Thomas More College and then went to professional baseball, playing in the major leagues for the Atlanta Braves, Cleveland Indians, New York Yankees, and Oakland Athletics. Born in Cincinnati in 1966, Justice spent 14 years in the majors and had a career batting average of .279 and hit 305 home runs. (Courtesy of Kenton County Public Library.)

**Haven Gillespie**

Haven Gillespie was born in Covington on February 6, 1888, and became one of America's most respected and well-known composers and lyricists. During his career, Gillespie would collaborate with many great writers and his songs were recorded by the likes of Dean Martin, Frank Sinatra, Michael Jackson, Louis Armstrong, Bruce Springsteen, and George Strait (seen in photograph below). Gillespie is best known for cowriting the Christmas classic "Santa Claus is Coming to Town." It was first sung on radio in November 1934 and became an instant hit. According to the *Encyclopedia of Northern Kentucky*, over 300 of Gillespie's songs were published, and he collaborated with over 300 other songwriters, wrote songs for 8 musical revues and variety shows, had 44 different musical publishers print his work, saw 20 songs chart, including 3 at number one, and his songs appear in 17 movies. Gillespie died in Las Vegas in 1975. (Above, courtesy of Kenton County Public Library; below, courtesy of Kenton County Public Library.)

## Dave Cowens

According to the *NBA Encyclopedia Playoff Edition*, "Dave Cowens earned a berth in the Basketball Hall of Fame because of his tenacity and work ethic as a mainstay of the Boston Celtics in the 1970s, leading the team to NBA Championships in 1974 and 1976." Born in Covington in 1948, Cowens was the NBA's Most Valuable Player 1973 and was selected in 1996 as one of the 50 best NBA players of all time. (Courtesy of Kenton County Public Library.)

**Northern Kentucky Brotherhood Singers**
The Northern Kentucky Brotherhood Singers started in the Covington's 9th Street Baptist Church and have toured nationally and internationally to perform in their "quartet style old-school a cappella fashion." Their gospel songs are inspirational and patriotic, motivating, and as they say, the R&B music makes people feel good. After 27 years, the singers continue to perform for audiences around the world. (Courtesy of Northern Kentucky Brotherhood Singers.)

**Joe and John Heving**
Joe and John Heving were two Covington brothers who both made the major leagues. John, a catcher, played eight seasons in the majors; and Joe, a pitcher, played 13 years. Joe died in 1970 and John in 1968. From 1942 to 1944, Joe was the oldest player in the American League. He appeared in 430 games and had a career record of 76 wins and 48 loses. John had a career batting average of .265 in 985 at bats. (Courtesy of Kevin T. Kelly.)

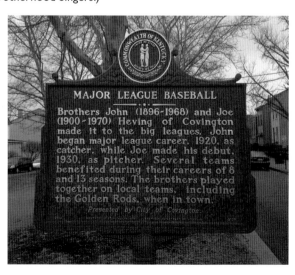

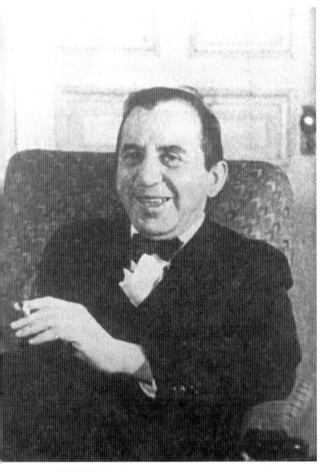

**Ben Lucien Burman**

Ben Lucien Burman is an author and journalist born in Covington on December 12, 1896, who graduated from Harvard University. He returned to Covington and taught at Holmes High School before working as an editor at the *Cincinnati Times-Star*. He wrote for many publications, including *Reader's Digest*. However, Burman is best known as an author about life on the river. He published 22 books, including his first in 1929, *Mississippi*. Other books followed, including *Steamboat Round the Bend*, which was made into a movie staring Will Rogers. It was Rogers's last and most successful film. During World War II, Burman became a war correspondent and was awarded the French Legion of Honor. He returned to writing books, including the poplar Catfish Bend series, published in many different languages. Burman died on November 12, 1984, in New York City. (Left, courtesy of Kenton County Public Library; below, courtesy of Kenton County Public Library.)

BEN LUCIEN BEHRMAN.

Literary Society, '09-'10-'11-'12-'13; Secretary of Literary Society, '10-'11; Orchestra, '11-'12-'13; Glee Club, '12-'13; Debating Society, '12-'13; Exchange Editor of *The Student*, '11-'12; Business Manager of *Student*, '12-'13; Midget Basketball Team, '10; Athletic Association, '12-'13.

*"I seen my duty and I done it."*

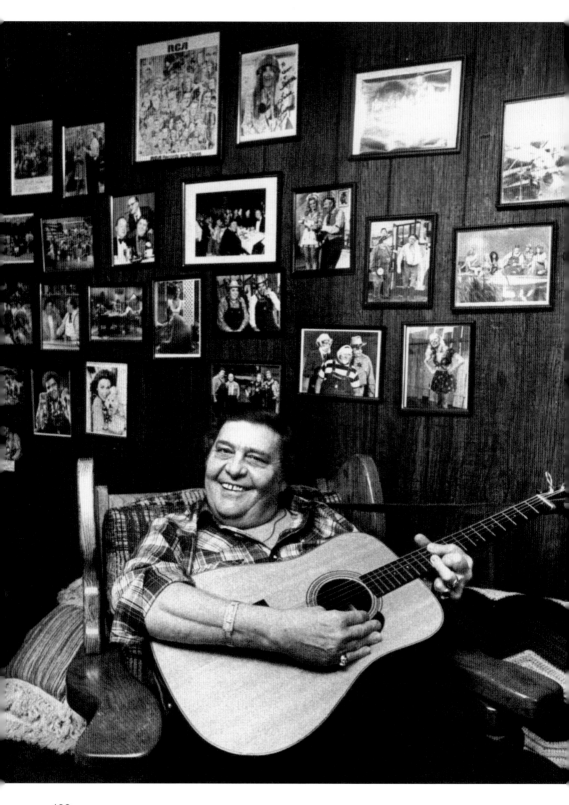

**Kenny Price** (OPPOSITE PAGE)

Kenny Price was born on May 27, 1931, in Covington at 1311 Holman Street. His family moved a few years later to Florence, Kentucky. Price became a very successful country music star and was nicknamed "the Round Mound of Sound,' because of his large frame. He was a popular cast member of the television show *Hee Haw*. Price received his first guitar at the age of five and by the age of 14 was playing on the radio at WZIP in Cincinnati. He served in the Army from 1952 to 1954 and upon his return starred on the *Midwestern Hayride* show at WLW Cincinnati. Price had several Top Ten country hits, including 'Walking on the New Grass," Happy Trucks," "Northeast Arkansas Mississippi County Bootlegger," and "The Sheriff of Boone County." He began his long run on *Hee Haw* in 1976. A very friendly person, Price was always happy to meet a fan. He died of a heart attack in 1987 at the age of 56 and is buried in Forest Lawn Cemetery in Erlanger. (Courtesy of Kenton County Public Library.)

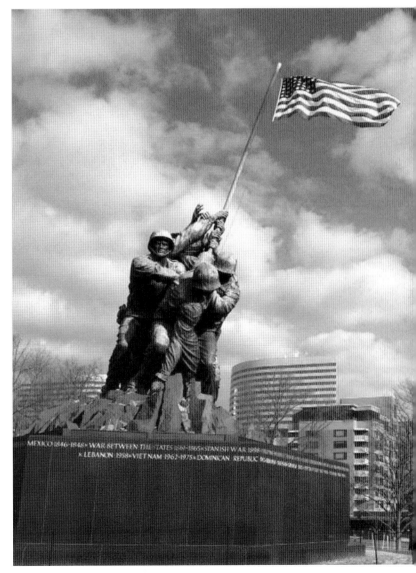

**Robert S. Allen**

Robert S. Allen was a journalist, author, and Washington bureau chief for the *Christian Science Monitor*. He was born in Covington on July 14, 1900, and was a veteran of both World War I and World War II, including serving on General Patton's staff during the Second World War. Following the war and up until 1980, Allen wrote a nationally syndicated column called Inside Washington. Allen became ill from cancer and committed suicide on February 23, 1981. He is buried in Arlington National Cemetery. (Courtesy of Kevin T. Kelly.)

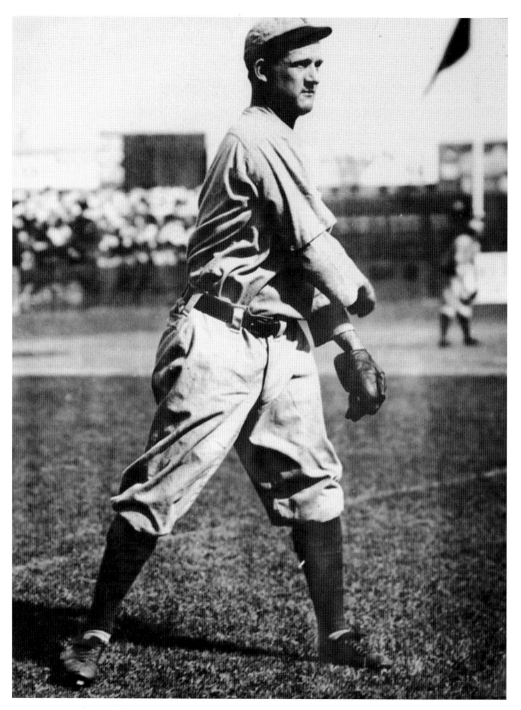

**Howie Camnitz**

Howie Camnitz was a starting pitcher in the major leagues for the Pittsburgh Pirates and Philadelphia Phillies. He was born in Covington on August 22, 1881, and played for 11 seasons. According to Baseball-Reference.com, in 326 games, Camnitz won 133 and lost 106. He died in Louisville, Kentucky, at the age of 78 in 1960 after a long career as a car salesman. (Courtesy of Northern KY Views.)

**Bill Sweeney**
Bill Sweeney was an infielder who spent eight years in the major leagues and was born in Covington on March 6, 1886. In 1,039 games, he had 1,004 hits for a career lifetime batting average of .272. In 1948, Sweeney died of a heart attack in Cambridge, Massachusetts, where he lived. During the flood of 1937, he helped raise money for victims by playing a small dramatic part at the Temple Theater in Newport. (Courtesy of Northern KY Views.)

**Una Merkel** (OPPOSITE PAGE AND BELOW)

Una Merkel began her career in the movies as a stand-in for Lillian Gish; the most famous time was in the 1928 film *The Wind*. She was born in Covington on December 10, 1903, to Arno and Elizabeth Merkel. The Merkels moved to Philadelphia when Una was a teenager. Later, she went to New York and took acting and dancing classes and her career started to launch. Her first leading role was in *The Fifth Horseman* in 1924, but she appeared on Broadway during most of the 1920s. She returned to film with famed director D.W. Griffith, including in the 1930 film *Abraham Lincoln*. Merkel had successfully made the transition from silent films to talkies. During the 1930s, Merkel achieved her greatest success, making almost 60 films. According to her obituary in the *New York Times*, "Merkel became a popular second lead in a number of films, usually playing the wisecracking best friend of the heroine, supporting actresses such as Jean Harlow, Carole Lombard, Loretta Young, and Dorothy Lamour." Merkel was an MGM contract actress from 1932 to 1938. One of her most famous roles was in *Destry Rides Again* in 1939, when her character Lillibelle gets into a famous catfight with Frenchie, played by Marlene Dietrich. In 1940, Merkel played opposite W.C. Fields in *The Bank Dick* and in both the 1934 and 1952 versions of the *Merry Widow*. Merkel won a Tony Award in 1956 for her Broadway performance in *The Ponder Heart* and was nominated for Best Supporting Actress in 1961 for her role in *Summer and Smoke*. Merkel appears in several Disney favorite films, such as *The Parent Trap* and *Summer Magic*. Her final role was with Elvis Presley in the 1966 movie *Spinout*, and Merkel has a star on the Hollywood Walk of Fame. In total, she was in around 100 films and died in 1986 at the age of 82. She is buried in Highland Cemetery in Fort Mitchell. A Kentucky State Highway Marker at Goebel Park honors Merkel for her contributions and career achievements. (Both, courtesy of Kenton County Public Library.)

**Kate Sweet** (ABOVE)
Born on February 8, 1956, in Covington, Kate Sweet was discovered after appearing on a late-night television show in Los Angeles. She went on to a successful childhood career, and her first film was at age two, with Ozzie and Harriet Nelson in *The Runaways* in 1958. Later, she appeared in other movies and television shows and, according to the Internet Movie Database, had 29 credits in her career. (Courtesy of Kenton County Public Library.)

**Randy Marsh** (LEFT)
Randy Marsh is a former Major League Baseball umpire from Covington. Born in 1949, he umpired in the National League from 1981 to 2009, including five World Series and four All-Star games. He was an umpire during the Cincinnati Reds World Series victory in 1990. Marsh attended Holmes High School and the University of Kentucky. (Courtesy of Kenton County Public Library.)

**Bob Arnzen**
A graduate of Xavier University, Bob Arnzen was drafted by the Detroit Pistons in 1969 and played in the old ABA for the New York Nets and Indiana Pacers and in the NBA for the Cincinnati Royals. Born in Covington, Arnzen had career totals of 111 games and 443 points. Arnzen also played for five minor league teams in the late 1960s and early 1970s. (Courtesy of Kenton County Public Library.)

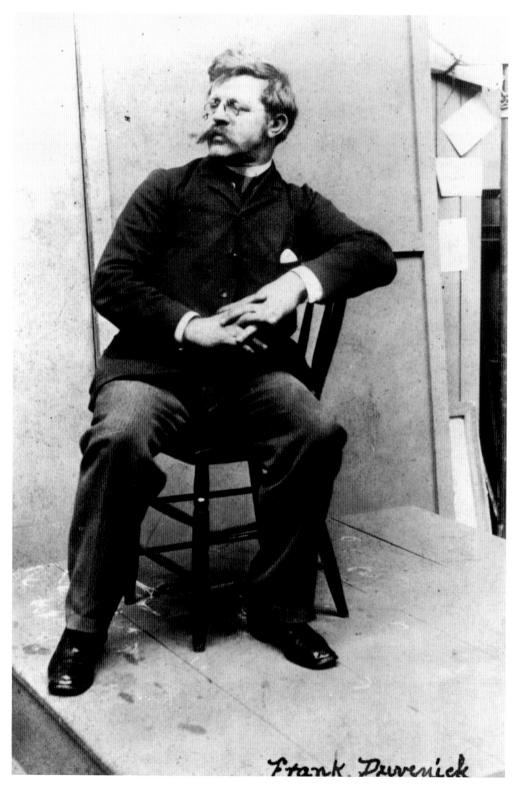

Frank Duveneck

**Frank Duveneck** (OPPOSITE PAGE AND BELOW)
Frank Duveneck was a world-renowned artist born in Covington on October 9, 1848. He was the son of German immigrant Bernhard, who died when Frank was a year old. His mother married Joseph Duveneck. Frank studied under Johann Schmitt and in 1869 went abroad to study in Germany, where he developed much of his style. It was there in 1872 he painted his finest work, *The Whistling Boy*, which is now owned by the Cincinnati Art Museum. Duveneck returned to Covington in 1873 and a year later began teaching at the Mechanics Institute and opened a studio on Greenup Street. Missing the excitement, he returned to Europe in 1875 and married one of his students, Elizabeth Boott, from Boston. They had one child, a son, Frank Boott Duveneck. Elizabeth died in Paris in 1888 and Frank was devastated. Upon his return, Duveneck started to sculpture and created an excellent image of his late wife. His productivity is said to have slowed after his wife's death and he lived in relative obscurity in Covington for the remainder of his life. Duveneck took a teaching position at the Art Academy of Cincinnati, where he shaped the minds and talents of many young artists. Some of his students included John Christen Johansen, M. Jean McLane, Edward Charles Volkert, and Russel Wright. In addition to *The Whistling Boy*, his other famous painting is *Lady with Fan* from 1873. In 1919, Duveneck died of cancer at the age of 71 and is buried in Mother of God Cemetery in Covington. His works can be seen in many great museums, but because of local efforts to buy his paintings, many can be seen in local venues. A beautiful life-size bronze statue of Duveneck stands in a park at Pike and Washington Streets in Covington. (Both, courtesy of Kenton County Public Library.)

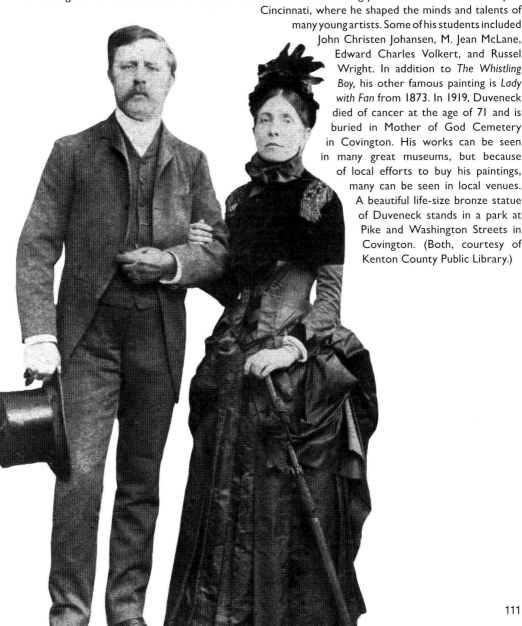

## Bill Cunningham

Bill Cunningham is a nationally syndicated radio broadcaster and television talk show host from Covington. Long a staple with WLW radio, Cunningham branched out nationally as conservative radio show host with *Live on Sunday Night, It's Bill Cunningham* and his own television show called *The Bill Cunningham Show*. Has been a regular on WLW since 1983 and has twice won a Marconi Award. Cunningham first started out his career as an attorney and was admitted to the Ohio Bar in 1975. Cunningham was born in Covington but grew up in Deer Park, where in high school he excelled in basketball. He was the Cincinnati leader in points his senior year and was named as one of the Top 100 Cincinnati-area high school basketball players in history. Cunningham played four years on the Xavier baseball team and later graduated from the University of Toledo Law School. Cunningham is seen above in Kenton County District Court defending pro wrestler Roderick George Toombs, better known as "Rowdy" Roddy Piper. (Courtesy of Kenton County Public Library.)

### John James Audubon

John James Audubon, while not from Covington, had a profound effect on the community. Born in 1795, he was a naturalist and painter best known for his works of American birds in their natural habitats. Audubon moved to Cincinnati in 1819 and, while employed as a taxidermist, painted cliff swallows in the Licking River Valley. This statue stands on Riverside Drive in Covington overlooking the Licking River where it joins the Ohio River. (Courtesy of Kevin T. Kelly.)

**Old Latonia Race Course–Racing Hall of Fame**
Two native Covingtonians are in the Racing Hall of Fame, including John "Mack" Garner, who was inducted in 1969. In 1915, Garner led US jockeys in wins and earnings. He often raced at Churchill Downs and the old Latonia racecourse. He died in 1936 after suffering two heart attacks. The other Hall of Famer is trainer Henry Forrest, who was born in 1907. During his career, Forrest won 1,837 races and $6,575,236 in earnings. He passed away in 1975 and was inducted into the Racing Hall of Fame in 2007. (Courtesy of Kenton County Public Library.)

## Mary Ellen Tanner

Mary Ellen Tanner was born in Covington on November 9, 1946, and is best known for being a regular on the *Bob Braun Show* on WLWT. The show was the top-rated live-entertainment program in the Midwest, and Braun hosted it from 1967 until 1984. Tanner began singing in public as a member of the Main Street Methodist Church and at age 12 appeared in park concerts with the Duke Moffitt big band. She appeared as a singer and contestant on the *Ted Mack Amateur Hour* and joined the cast of the *Bob Braun Show* as a regular in 1978. Tanner stayed with the program until it ended in the 1984 and became a household name in the region. After leaving the show, she entertained locally and including with several different orchestras. Tanner died at her Covington home on May 3, 2014. (Courtesy of Kenton County Public Library.)

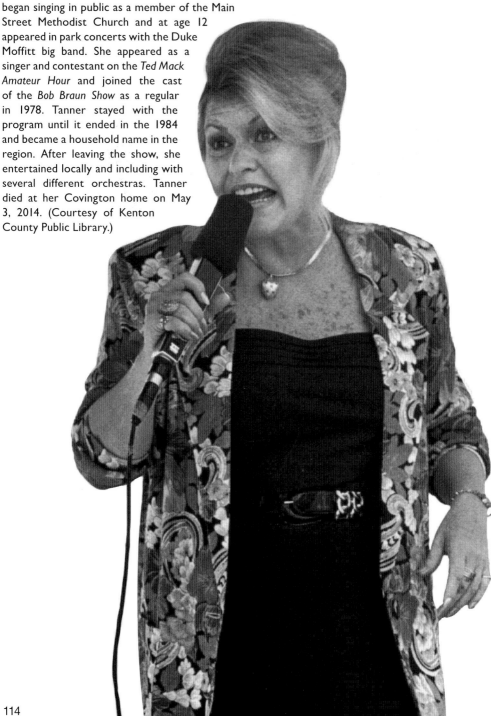

# CHAPTER SIX

# Educators

Public education schools began in Covington in 1823. There was one teacher, a budget of $800, and 20 students. Previously, only private, for-pay schools existed, but once public schools were introduced, they continued to grow as did the population of the city. Today, there are over 4,000 students preschool to high school in the Covington School District. Also, Covington Latin School continues to serve as one of the best private schools in the region, if not the state. The first brick school in Covington opened in 1864 and consisted of 12 rooms. There are many components to the Covington school system. One, the Lincoln-Grant School was the last in a line of African American schools opened in Covington. As in any community, so much is defined by the quality of the school system. Covington Independent Schools continues to suffer from urban problems plaguing cities around the country. Education defines a community and is the foundation on which most cities are built; the public and private schools of Covington have played a significant role in defining the city and the lives of the people profiled in this book. From the founding of the city 200 years ago to the 21st century, Covington education has been at the forefront of innovation and creativity. The future of Covington and the education of its population go hand and hand. According to *Vision 2015, the Regional Strategy for Northern Kentucky*: "A concentration of highly educated people is key to achieving a region's economic success. After all, regions prosper by virtue of their people. Therefore, Northern Kentucky set the goal of exceeding national education performance standards at every level." The individuals profiled in this chapter are people who have helped shape education in Covington. Some taught outside the school system and had long-lasting impacts, such a Behringer and Crawford. They are a very few examples of the men and women who have worked or graduated from public and private schools in Covington and helped shape the minds of so many of its citizens. Many of the people profiled in this book went on to great things in large part because of the educations they received in Covington. Today, the same is true. There is no telling how many people are going through the schools located in Covington who will make a great impact and become well known. However, just as important are all the others who will stay in Covington or the region to raise their families. They will define Covington in the future.

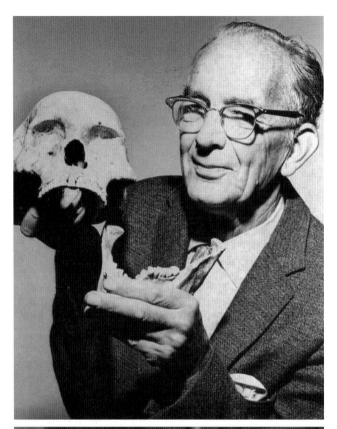

### Ellis Crawford

Ellis Crawford was an archaeologist, geologist, and naturalist and one of the namesakes of the Behringer Crawford Museum in Devou Park in Covington. Crawford was born May 21, 1905, and was self-educated. He has been described as the region's greatest supporter of its prehistoric heritage. Crawford led archaeological work in Boone County, including at Big Bone and the Gaines Farm. His friendship with William Behringer led to the creation of the museum in Devou Park. Behringer left his vast collection of artifacts to the City of Covington, and Crawford suggested they be house in the old Devou home. Crawford died in Covington on October 4, 1972, but his legacy lives on through the museum bearing his name. (Above, courtesy of Kenton County Public Library; below, courtesy of Kenton County Public Library.)

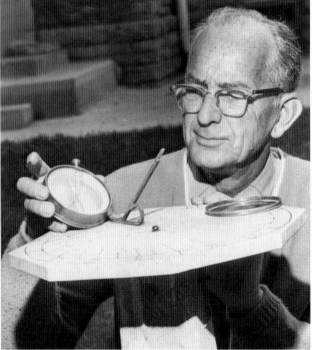

## William Behringer

A man who traveled the world, William Behringer was born in Covington on January 10, 1884, and died there on December 10, 1948. Covington was the recipient of his life's work and generosity. He was a noted taxidermist and naturalist who collected animal and geological specimens from around the globe. His collection helped form the basis of the Behringer-Crawford Museum in Covington and include some truly unique items, such as a shrunken head from the Amazon. In 1950, the William J. Behringer Memorial Museum opened and Crawford served as the first director. Later renamed the Behringer-Crawford Museum, it today stands as a gem in the region and a true testament to both men and their accomplishments. Behringer is buried in Highland Cemetery in Fort Mitchell. (Courtesy of Kenton County Public Library.)

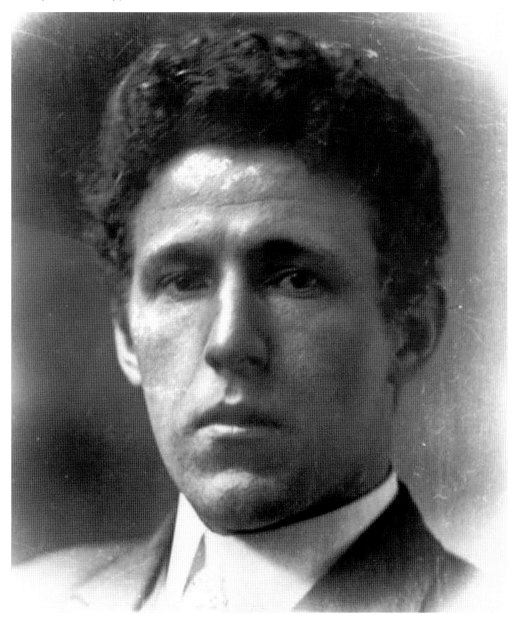

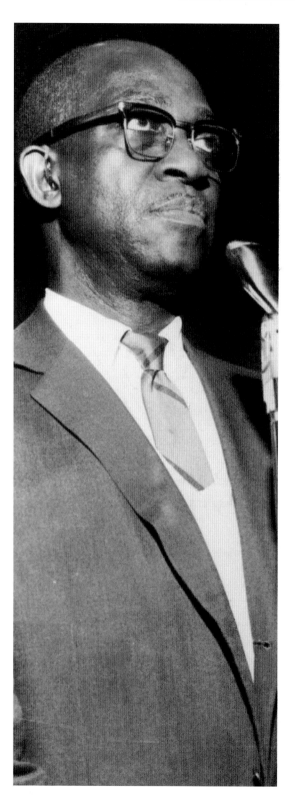

**M.L. Matthew Mastin**
M.L. Matthew Mastin was principal of
the Lincoln-Grant School. He began his
tenure as principal in 1964. During his time
there, the African American school was
integrated, joined the Covington School
District, and was renamed the Twelfth
District School. Mastin left in 1973, three
years before the school closed. (Courtesy
of Kenton County Public Library.)

A

Born
June 21
1867
at
Columbus
Ohio

Ω

Died
January 18
1944
at
Covington
Kentucky

*I accept death lovingly when the Lord wills it, in expiation of my sins and in adoration of His desires*

+ *Francis W. Howard*

**Bishop of Covington**

PRAY FOR ME

**Rev. Francis Howard**
Born on June 21, 1867, the Reverend Francis Howard was the fifth bishop of Covington but served many years in the priesthood in Columbus. As bishop, he was particularly concerned with education and oversaw the creation of several high schools in the diocese, notably Covington Catholic, Covington Latin, and Newport Central. Bishop Howard also made Villa Madonna College (now Thomas More College) "a diocesan institution," according to his Kenton County Library biography. He died in 1944 in Covington and is buried at St. Mary's Cemetery in Fort Mitchell. (Courtesy of Kenton County Public Library.)

## William Grant

William Grant was a lawyer and businessman who, after becoming a state representative, led the way for the creation of the first public African American school in Covington. Born in 1820, he deeded over his own land for the school. Later named the William J. Grant High School, it opened to an enrollment of 200 students. In 1932, a new school was opened on Greenup Street for all grades. William Grant died in 1882, two years after the original opening of the school. He is buried in Linden Grove Cemetery in Covington. (Above, courtesy of Kenton County Public Library; below, courtesy of Kenton County Public Library.)

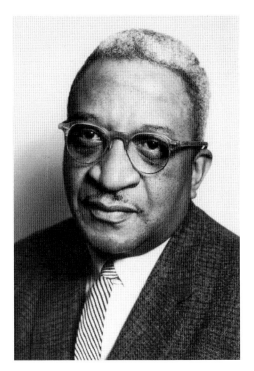

**R. Hayes Strider**

R. Hayes Strider was a band director of Lincoln-Grant School and later went on to a distinguished career in music education. He died in 1968 and at the time was working on a book on Negro contributions to music. Born in Lexington, he went on to earn his doctorate in education from New York University. At the time of his death, Strider was professor and chairman of the Department of Music at Morgan State College in Baltimore. (Courtesy of Kenton County Public Library.)

**Alvin Garrison**

Alvin Garrison was named superintendent of the Covington Independent School System in May 2013. According to the *River City News*, Garrison told the crowd assembled at the board of education building, "I'm honored to have this opportunity," after a standing ovation that followed the board's vote. "I think this district is really a special place with tremendous potential and I look forward to serving as superintendent." Garrison came to Covington from John Hardin High School, where he served as principal. (Courtesy of Alvin Garrison.)

**Dr. James Averdick** (OPPOSITE PAGE)

Dr. James Averdick was a local politician and a physician by trade in Covington. Averdick was born in Cincinnati on Christmas Day in 1852 and rose to be one of the leaders of the local Democratic Party. He attended St. Mary's Institute in Dayton (now the University of Dayton) and graduated from Ohio Medical College in Cincinnati. He began his practice in Covington and later served two terms in the state legislature and one term as Kenton County coroner. However, Averdick had a tremendous impact on Covington schools during the course of his lifetime. Averdick joined the board of education of the Covington school system in January 1886 and served the rest of his life. The 40 years he was on the board still represents the longest time anybody has served in Covington history. According to his biography at the Kenton County Library, "During these years of service, the Covington Public Schools expanded in scope and professionalism. Averdick took great interest in the construction of new public school buildings. His attention to detail and good business sense allowed the district to build numerous structures that were both modern and affordable." Despite his service to the board, Averdick continued to practice medicine from 1873 until 1931. He also was chief of staff for St. Elizabeth Hospital for several years. Averdick died on August 1, 1931, in Covington and is buried in Indiana. (Courtesy of Kenton County Public Library.)

## Asa Drury

Asa Drury was born on July 26, 1802, in Massachusetts and graduated from Yale in 1829. He studied for the ministry and was ordained in 1832 as a Baptist. Following several positions, Drury moved in 1845 to Cincinnati, where he was one of the first faculty members at the Western Baptist Theological Institute in Covington. In 1855, he left the institute to teach in the Covington school system. He became a principal of Covington High School in 1853 and on January 26, 1856, became the first superintendent of the Covington Public School System. According to the Kenton County Library biography of Drury, his "work as superintendent was exemplary. He was given several raises by the board. These raises, however, violated the charter of the school system (his salary had increased beyond the legal limit imposed by the school charter). In 1859, the members of the board reduced his salary so it would be in compliance with the charter. Drury resigned on the spot. In 1859, Drury opened the Judsonia Female Seminary in the old Baptist Theological Institute building (the institute had closed several years earlier)." Later, Drury moved to Minnesota, where he died on March 18, 1870. He is buried in Highland Cemetery in Fort Mitchell. (Courtesy of Kenton County Public Library.)

**Carl Clifton Faith**

Carl Clifton Faith was born in Covington and is a world-renowned mathematician. He attended Holmes High School, is a veteran of World War II, and graduated cum laude in mathematics from the University of Kentucky. He obtained his master's and doctoral degrees from Purdue University. Following graduation, Faith served as a mathematics teaching assistant for four years and left Purdue for Michigan State University, where he was an assistant professor for two years. He then accepted an assistant professorship at Pennsylvania State University in State College. According to his obituary, "In 1959–1960, he was a Fulbright-NATO post-doctoral fellow at Heidelberg University, Germany. He was appointed Full Professor of Mathematics at Rutgers University, New Brunswick & Piscataway, New Jersey, in 1962, and taught there to his retirement in 1997." In 2008, he was honored by Holmes High School by being inducted into their Hall of Distinction. Faith's mathematical research was in abstract algebra, Galois theory, and ring theory, including module theory, and he is the author of many books and publications. Faith passed away on Sunday, January 12, 2014. (Courtesy of the Faith family.)

# BIBLIOGRAPHY

bioguide.congress.gov

Dunham, Tom. *Covington, Kentucky, A Historical Guide*. Bloomington, IN: AuthorHouse, 2007.

Kenton County Library, Covington, Kentucky biographies.

msa.maryland.gov

Reis, Jim. *Pieces of the Past 1*. Covington, KY: Kentucky Post, 1988.

————. *Pieces of the Past 2*. Covington, KY: Kentucky Post, 1991.

Tenkotte, Paul A. and James C. Claypool. *The Encyclopedia of Northern Kentucky*. Lexington: University of Kentucky Press, 2009.

www.britannica.com

www.findagrave.com

www.imdb.com

# INDEX